INTRODUCTION

Not being noticed when you're pointing
a camera at someone is one of the most
important, but hardest, things for a
photographer to do; allowing them to catch
people being themselves. Pat's put in his time
with me, like Jane Goodall living amongst the
primates, and is able to pull it off. He lived with
me off and on, starting when I dropped out of
highschool and moved to Arlington, Virginia
at the age of 16, probably for similar reasons
to Pat. Even early on we liked bringing our
friends on tour with Modest Mouse to help,
and sometimes just to stare blankly inside
the hoods of our broken vehicles on the side
of the road, but mainly for fun and company.
It is our dumb luck that he is such a great
photographer.

-Isaac Brock

MODEST MOUSE

MODEST

PHOTOGRAPHS BY

pH powerHouse Books BROOKLYN, NY

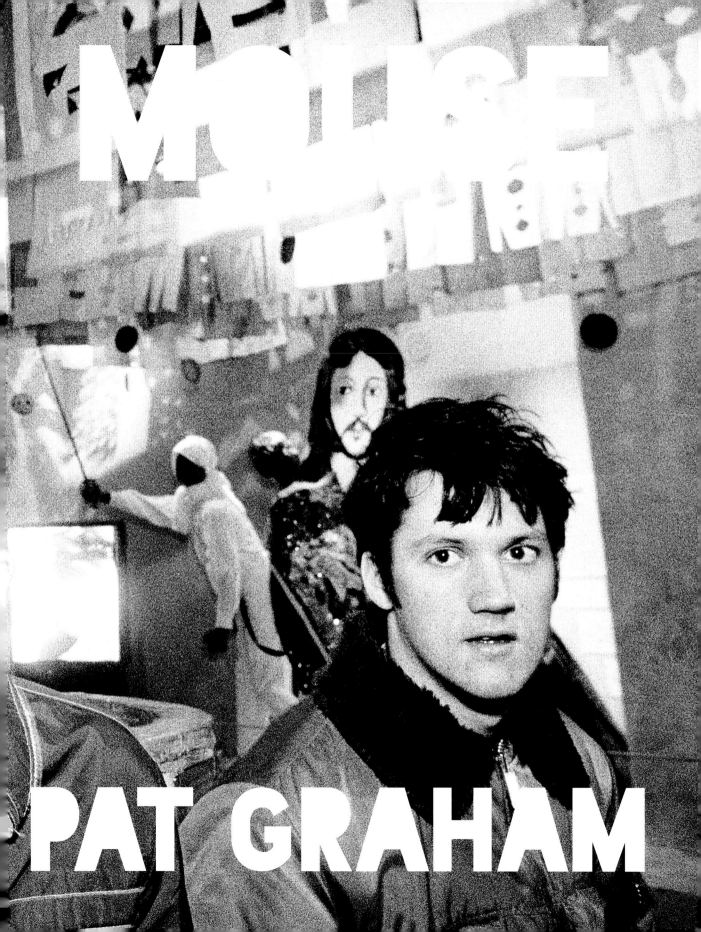

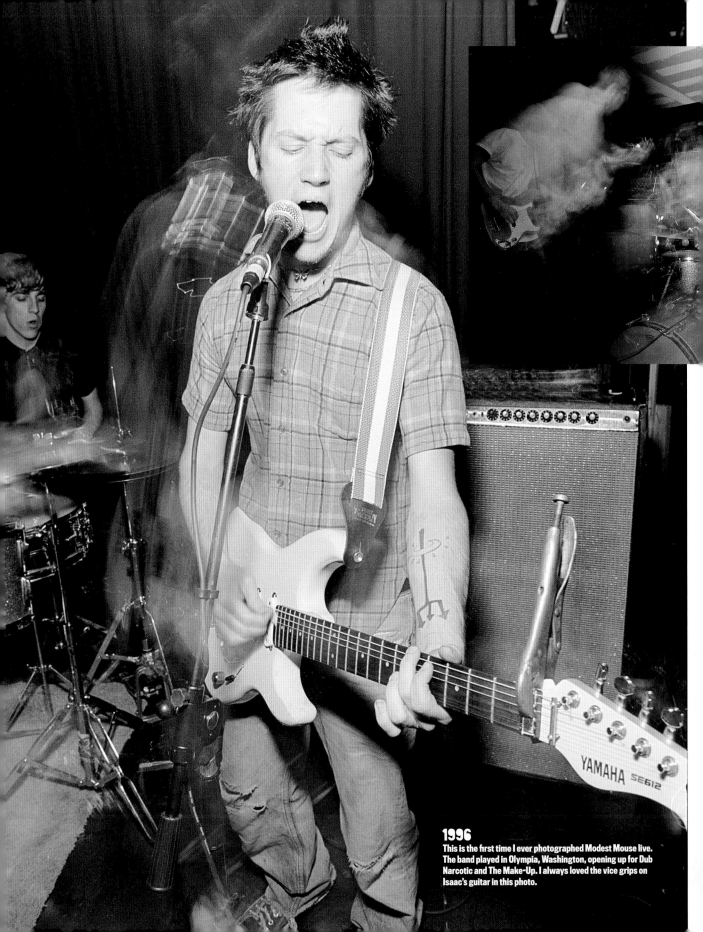

1996
This is the first time I ever photographed Modest Mouse live.
The band played in Olympia, Washington, opening up for Dub
Narcotic and The Make-Up. I always loved the vice grips on
Isaac's guitar in this photo.

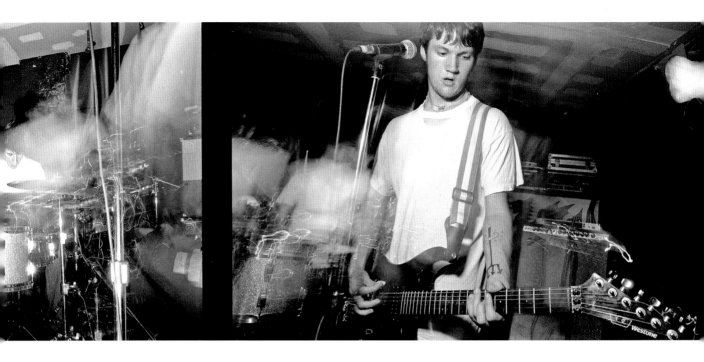

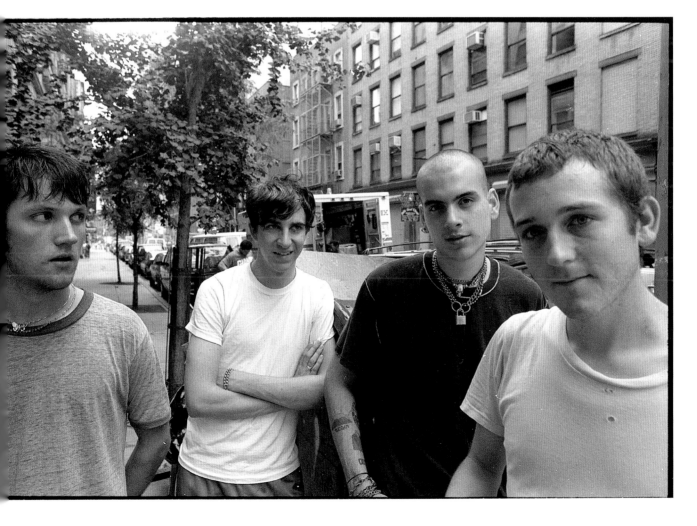

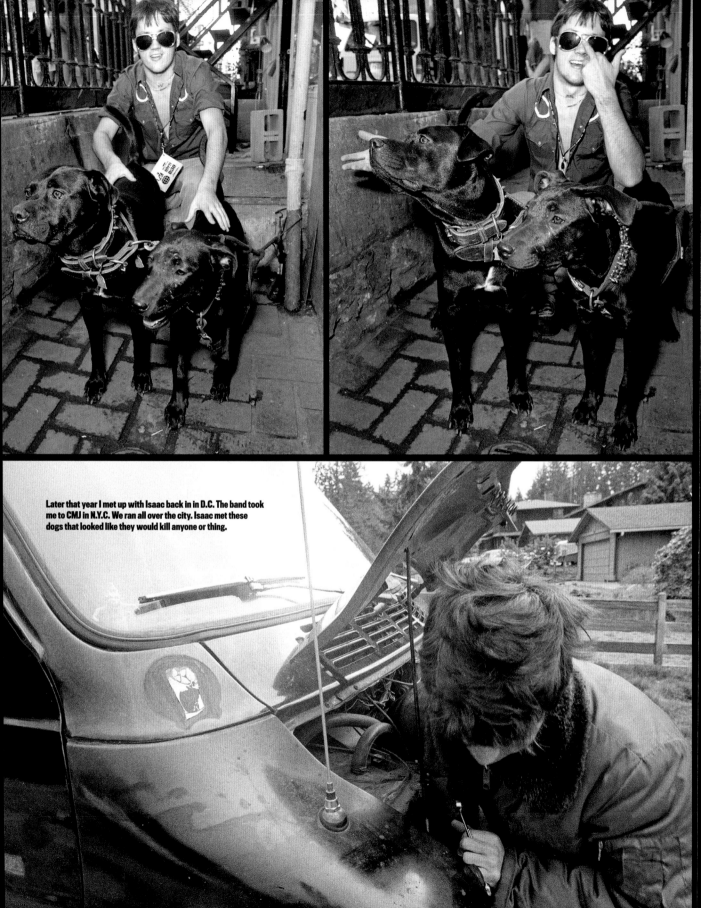

Later that year I met up with Isaac back in in D.C. The band took me to CMJ in N.Y.C. We ran all over the city. Isaac met these dogs that looked like they would kill anyone or thing.

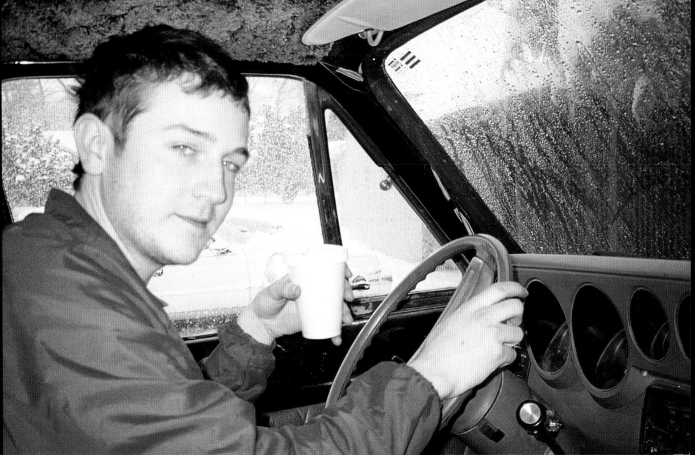

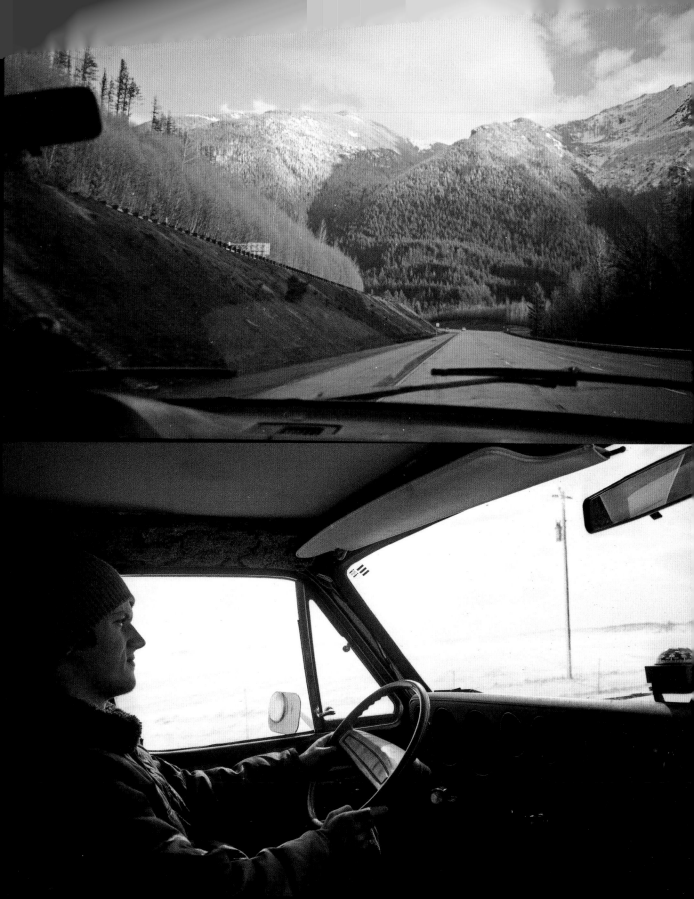

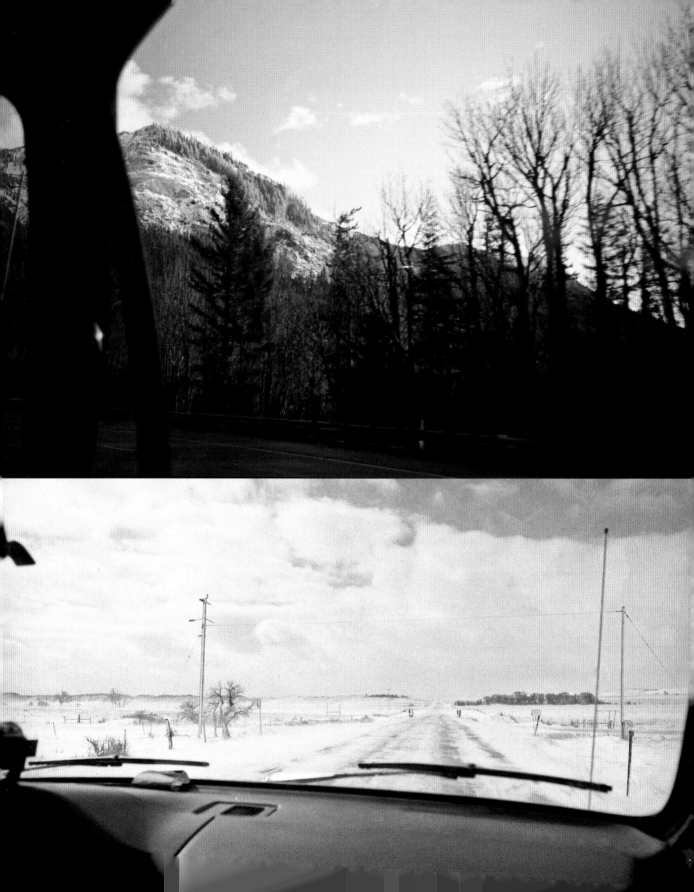

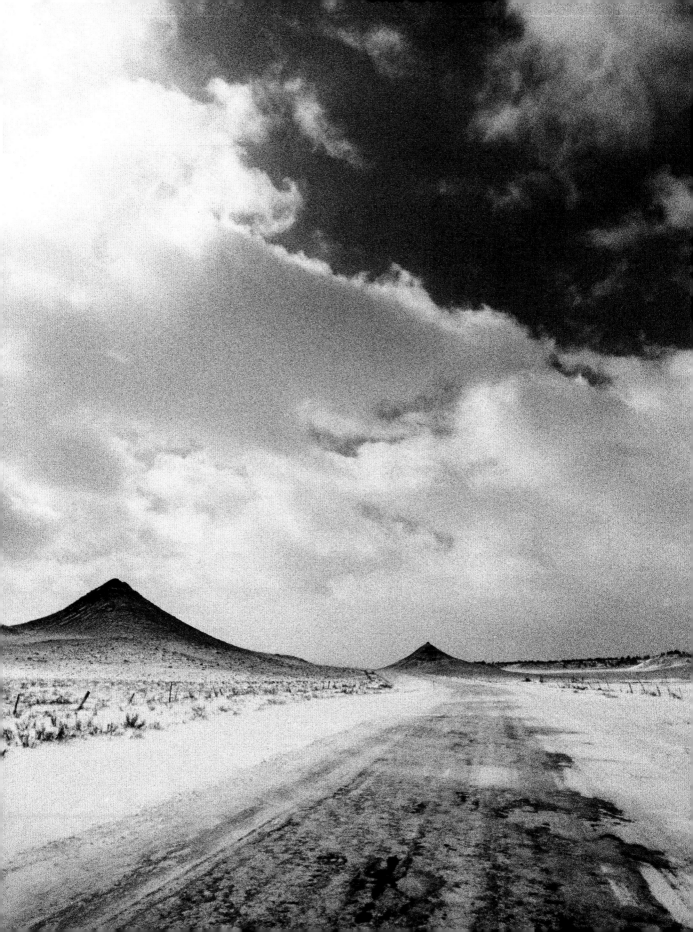

APRIL 1997

Isaac invited me to go on the first U.S. tour. I flew out to Seattle from D.C. I was excited, as this would be my first road trip across the U.S.A. and I was going in the new (very used), wall-to-wall carpeted, extended van to photograph Modest Mouse. The tour was in spring, so we packed light. First stop was Pullman, Washington followed by Chicago, three days later. Normally this would be plenty of time to drive that far. The day after the Pullman show we hit the road. Driving through Washington and into Montana was beautiful. I had my camera pressed against the window as we drove down the highway. Soon snowflakes began to cover the road and we all became entranced by the blowing snow. I kept noticing road signs that said, "Get your chains on," and "Bridge may be slippery." As we crept along for hours the snow got deeper. Eric had just taken over driving and I sat in the front. I remember releasing my seatbelt to take another picture out the window and as I did we began to fishtail on one of those slippery bridges. I looked at Eric in horror as he tried to get control of the van.

Next thing I knew the van spun completely around and we were headed straight for the side of the bridge and all I could see was down. Smash...the van crashed and stopped suddenly. The guardrail had kept us from going over. We were now stopped perpendicular and looking over the bridge. Traffic came to a halt, and people surrounded the van... We all got out and were very shaken up.

Chains, we need chains now! Isaac got in the van and backed it up. The van made a loud crunching sound as the fender was pressing up against something. Luckily it still ran in the forward direction. We got off the highway at the next exit and headed to a gas station to purchase chains. With our chains securely in place we headed back to the highway. Unfortunately the idea for chains was now more of a hazard than help since the road was somehow clear. Our chains were now throwing off sparks as they ground against the clean highway. After a few miles and lots of strange looks from other drivers we pulled over so Isaac and Eric could remove the chains. They had somehow or another damaged the lines that bring fluid to the brakes. This did not stop us from driving. At this point we had been driving all day and had almost died once. Out of our minds we stopped for food at a truck stop. As we sat and ate the radio in the background was announcing all the roads in the area were closing. All the roads except one were now closed. This would be our way out of the blizzard and on to Chicago.

Back in the van, feeling a little better, we started down the last open road. The only light was from our headlights beaming through the snow. Every few miles we would hit a large drift and the van would jump. As we sledded along the visibility became worse and worse. I was driving and started to become very hypnotized by the snow when I spotted a dark figure in the middle of the road up ahead. I slowed down to a stop and my stomach turned. In the headlights was a cow standing in the middle of the road frozen. The cow's face was looking a lot like Jack Nicholson's at the end of *The Shining*. It scared the shit out of me. I drove around it and we carried on, continuing through the drifts, and now feeling a little nervous about the situation.

Poof...the van stopped. We were stuck in the middle of a drift with no road or any other cars in site. As it was April, we had no hats or gloves. The closest thing was a pair of socks.

With socks on our hands we started to try and dig out while one person hit the gas in the van and spun the wheels. Nothing was helping. The road seemed to be gone and we were not moving, just getting colder. At one point we decided to use a piece of wood that was the top of a storage box in the van as a traction device. I shoved it under the back wheel. Isaac hit the gas and this flat box top went flying like a sled across the snow. Isaac went to look for it only to come back wet, as he had somehow stepped in a drift that had a river below it.

By this point we were really cold, my hands and feet were numb. We sat in the van with the engine running. The van then sputtered out and died.

About ten minutes after this we noticed some headlights behind us, about 100 yards back through the snow. After crawling through the snow we reached a little red mustang with a cowboy dressed in Marlboro cigarette clothes behind the wheel. He opened the door and said in a drawl, "Climb in boys I barely made it this far we aint going nowhere tonight." Frozen solid we all climbed in and waited for morning. This ended the first day and night of our three-day drive to Chicago. As the sun rose on our second day, we all watched from the inside of the car as a large hay bailer attempted to pull the van through the drift. This ended with the bailer tipping over next to the van. A second bailer drove up and had success. Having not really slept we jumped back in the van and by a freak chance it started. The day was bright and the snow looked amazing. Being able to see the terrain now, it was lucky we had been stuck. As we drove slowly over the hills I could see huge drops on either side of the road. I was now feeling less likely to die and a little warmer, so I began taking pictures of the surreal terrain out the window. On one of my last shots a hawk flew high above the road into my viewfinder just as I was clicking the shutter.

We made it through the blizzard and out of Montana. The van kept going but did seem to have some problems, and we had to keep the heat off so it wouldn't overheat. At the end of day two we made it to a Jiffy Lube/garage somewhere in Minnesota. Sadly we got there too late and the place was closed. So we spent the night in the parking lot waiting for it to open. In the morning Isaac fixed the van and we carried on to Chicago. By the time we made it to The Empty Bottle in Chicago it was one in the morning and the band was supposed to play at ten. We unloaded quickly and MM managed to play a couple songs to a few people before the place closed.

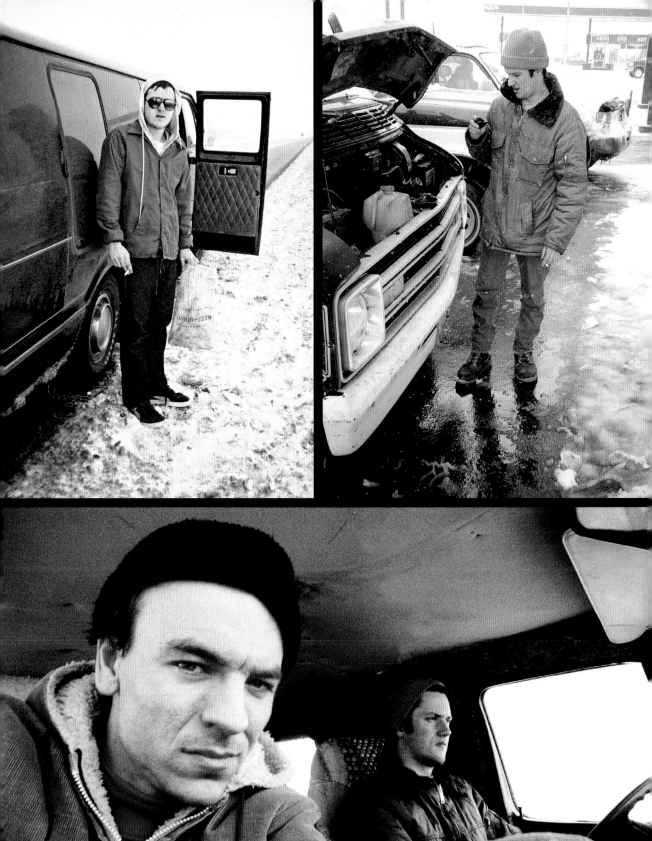

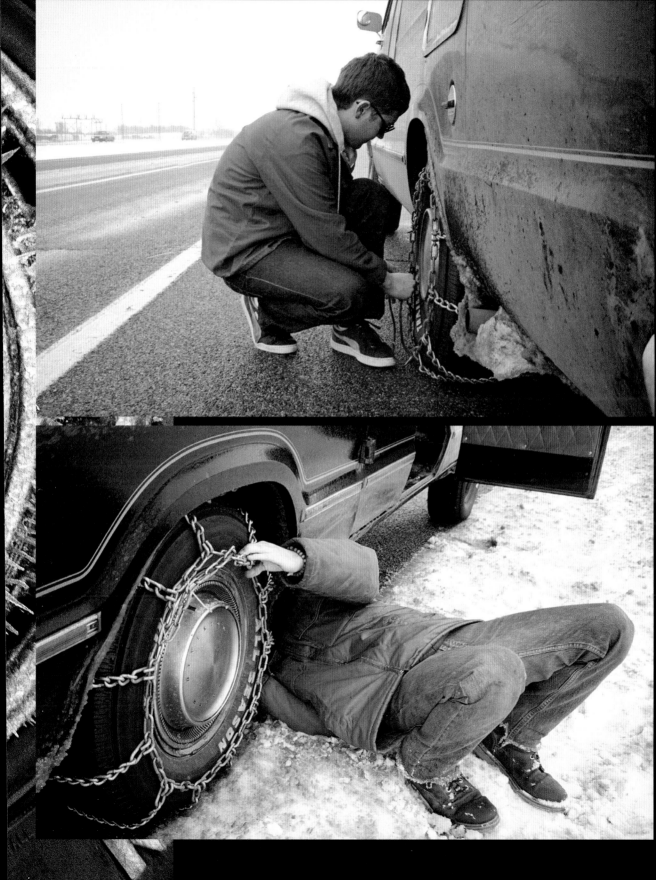

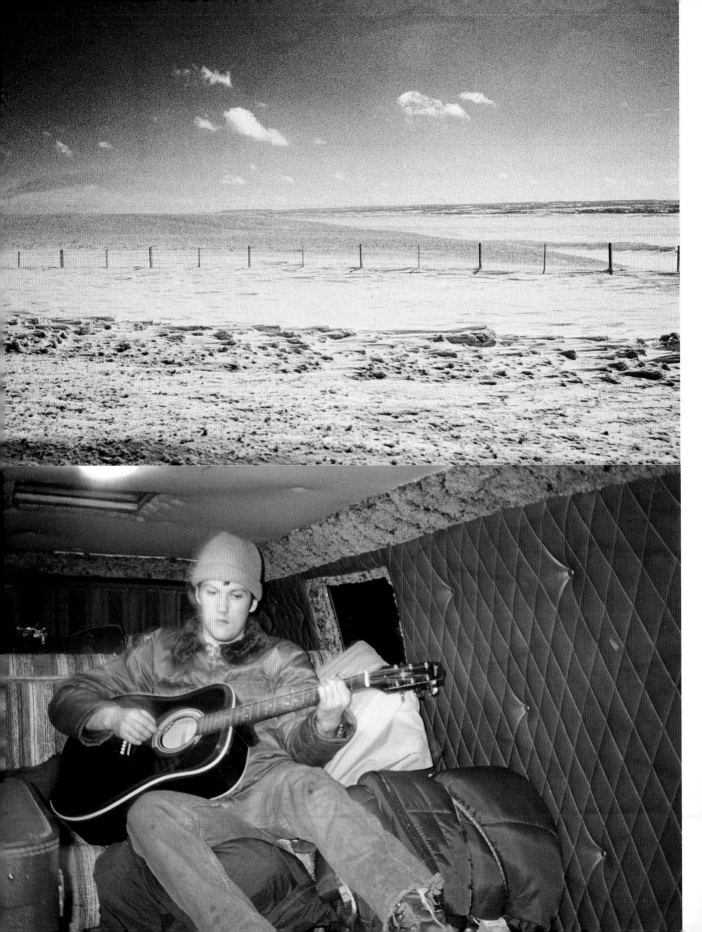

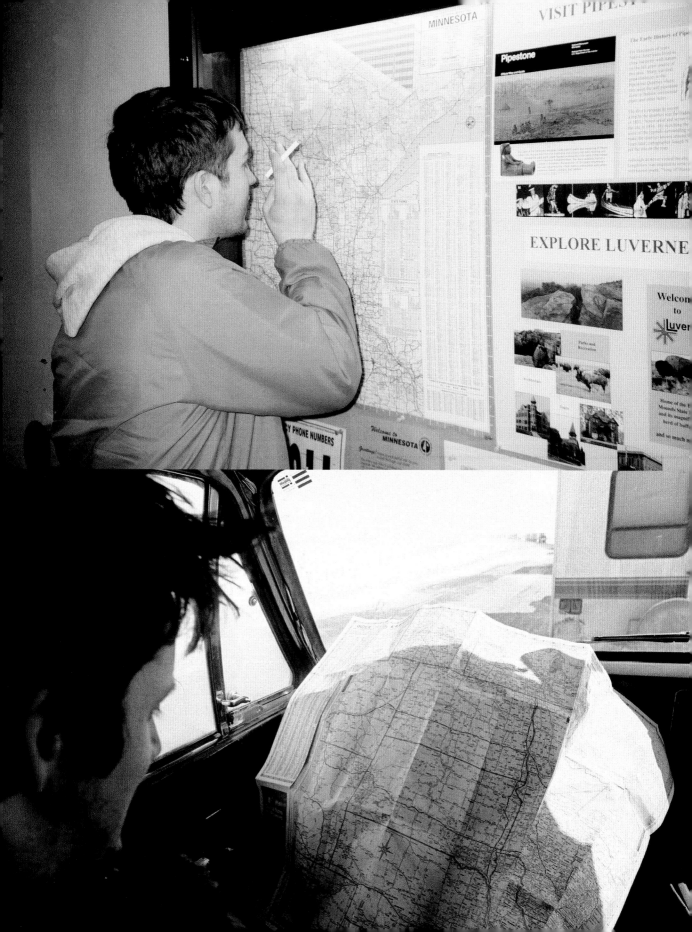

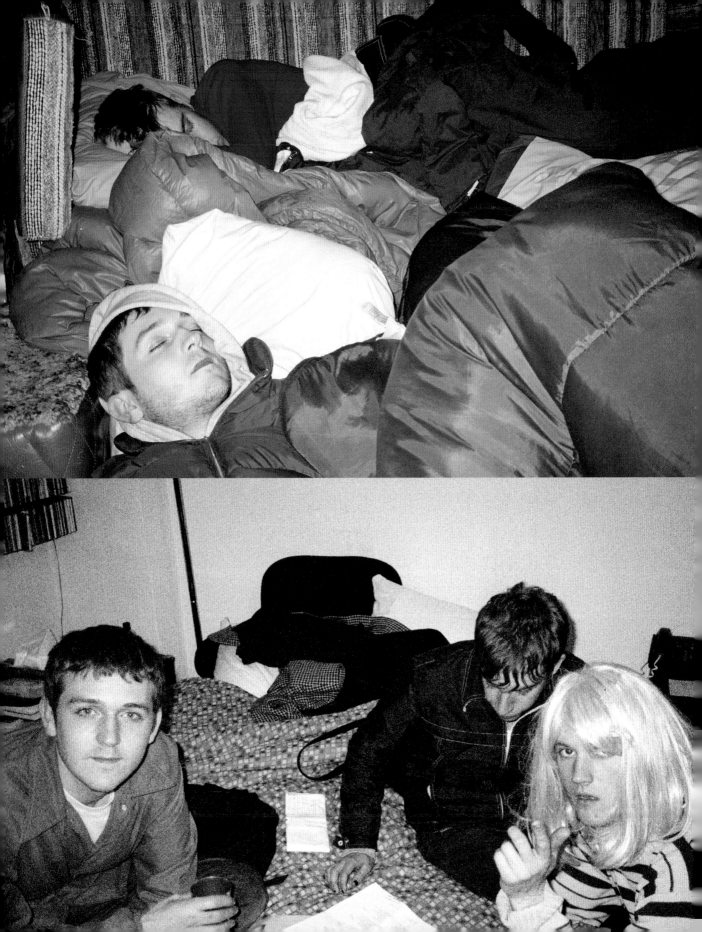

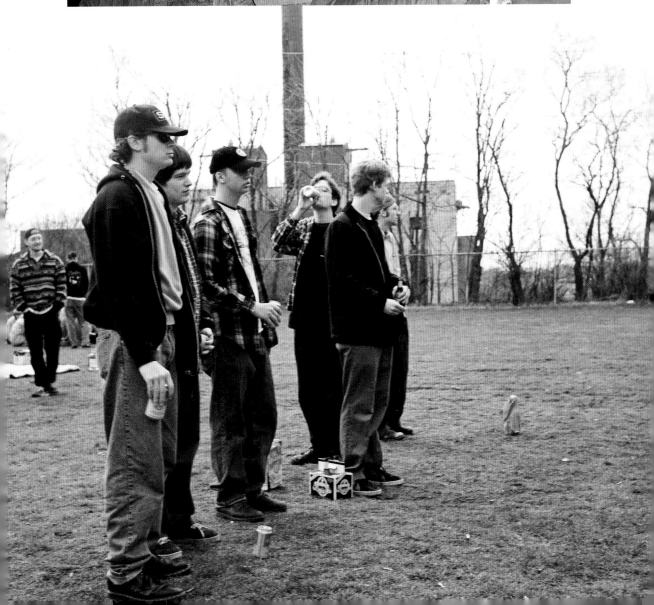

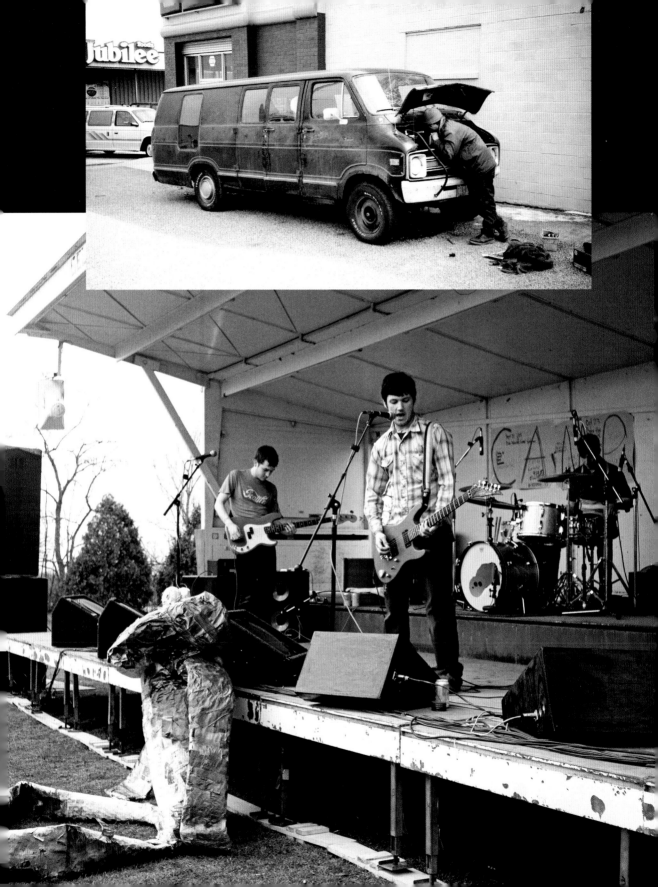

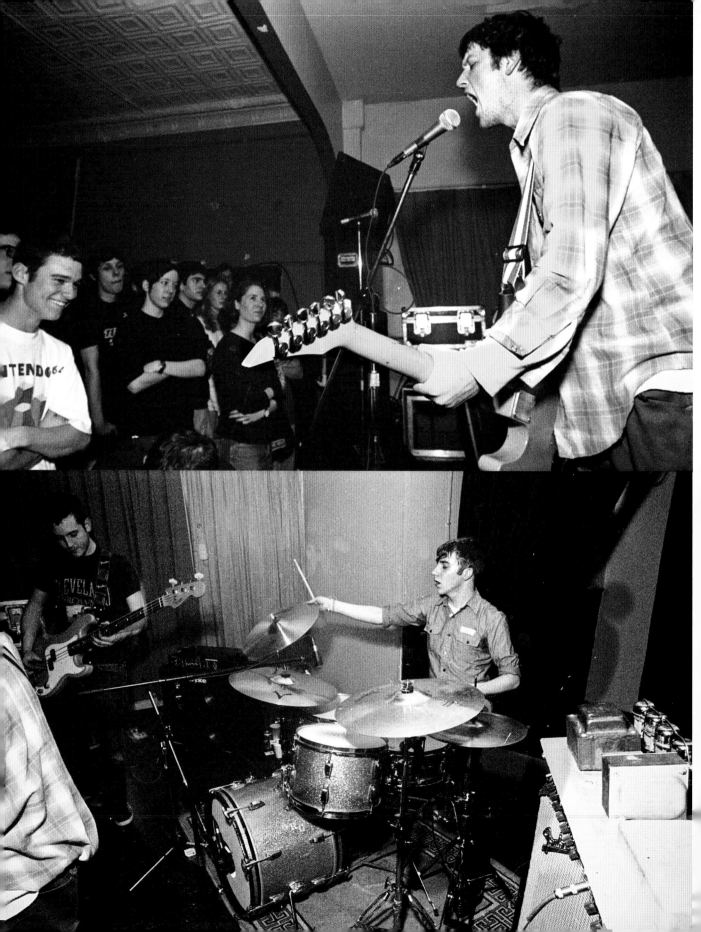

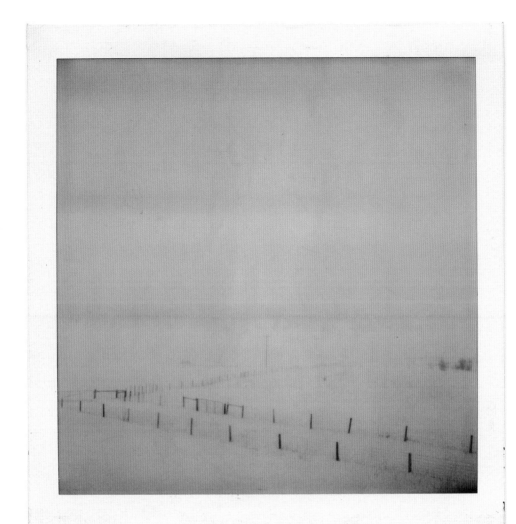

4-5-97

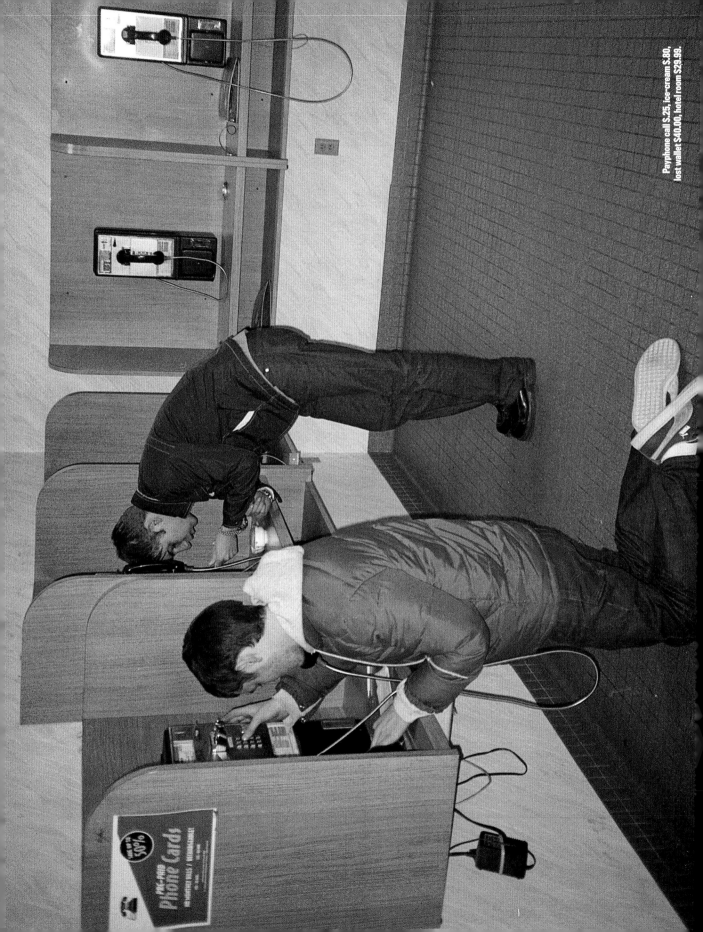

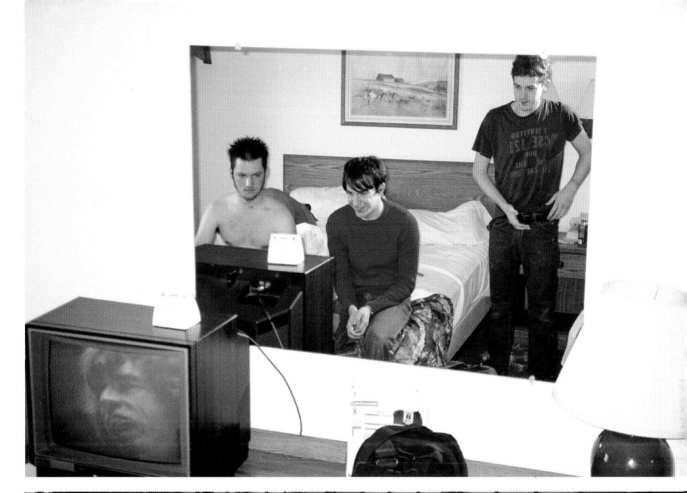

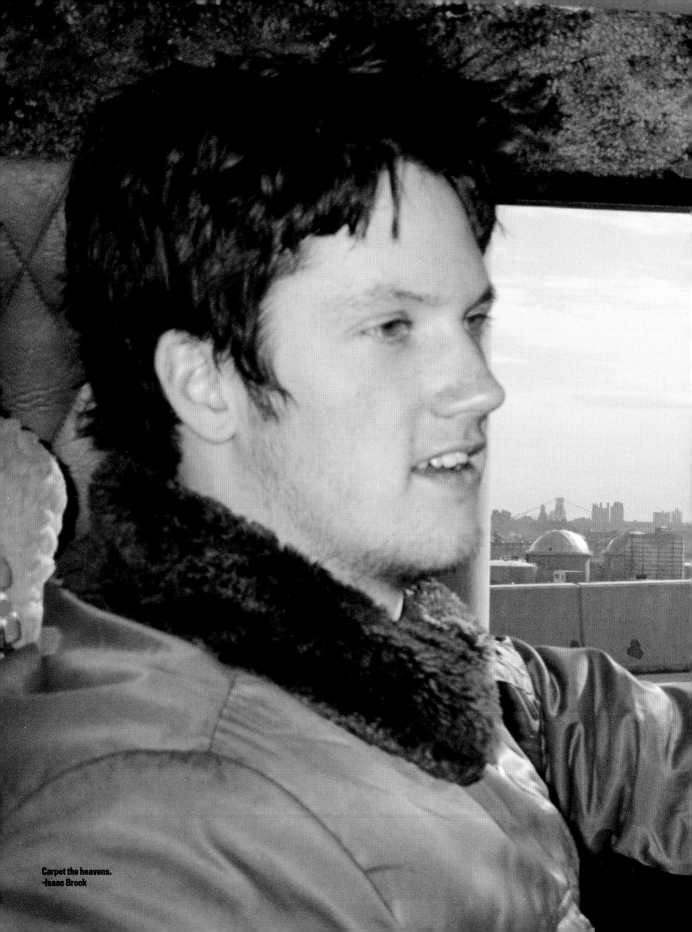

Carpet the heavens.
-Isaac Brock

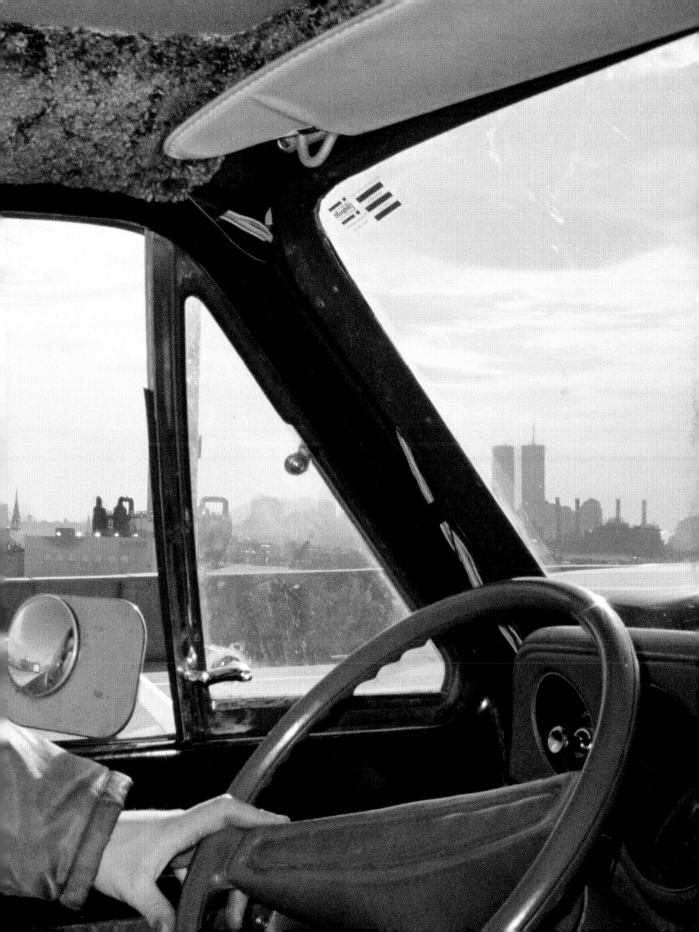

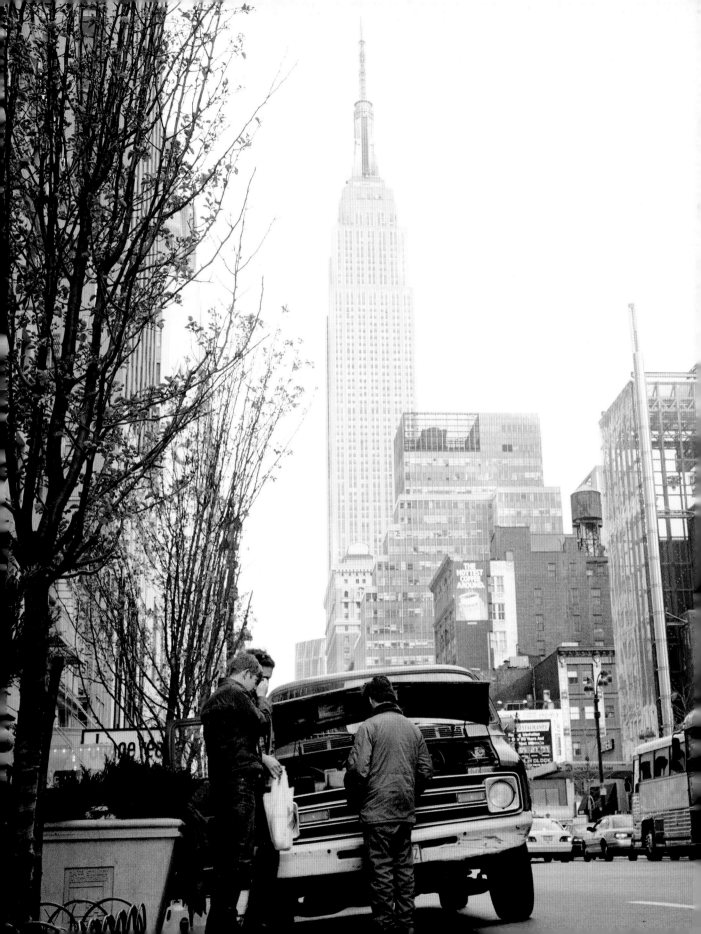

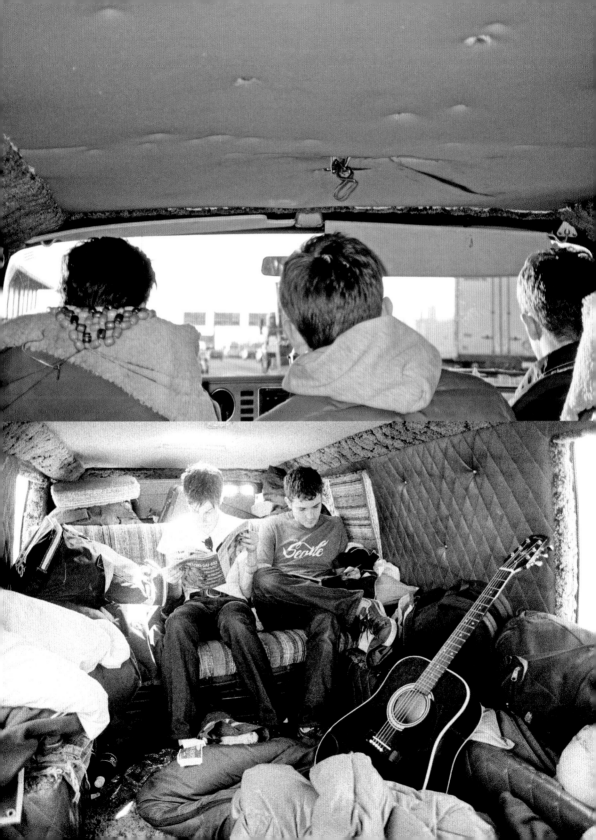

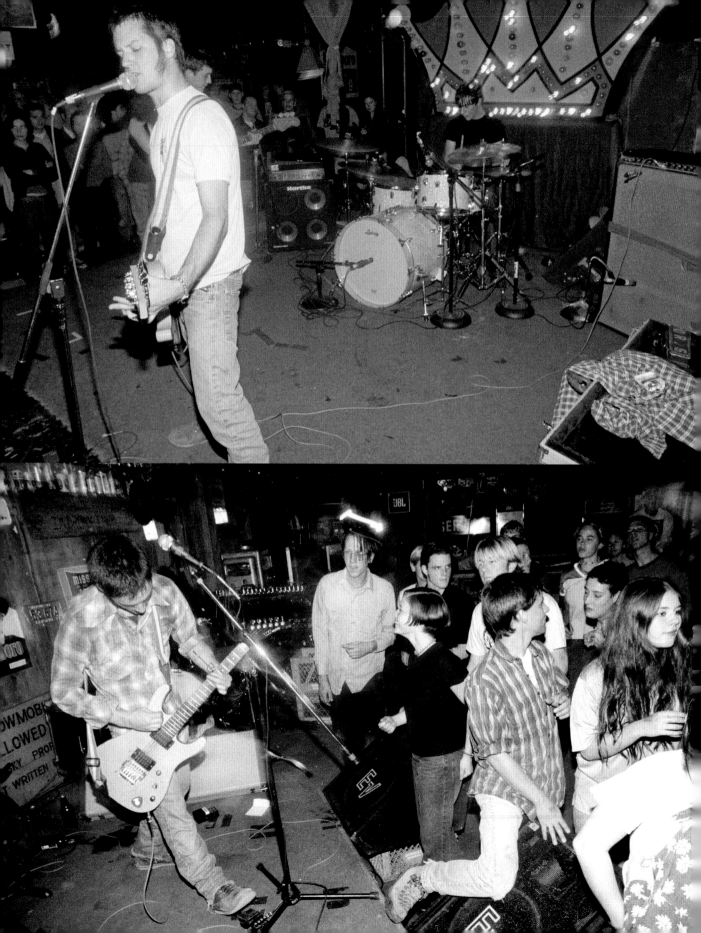

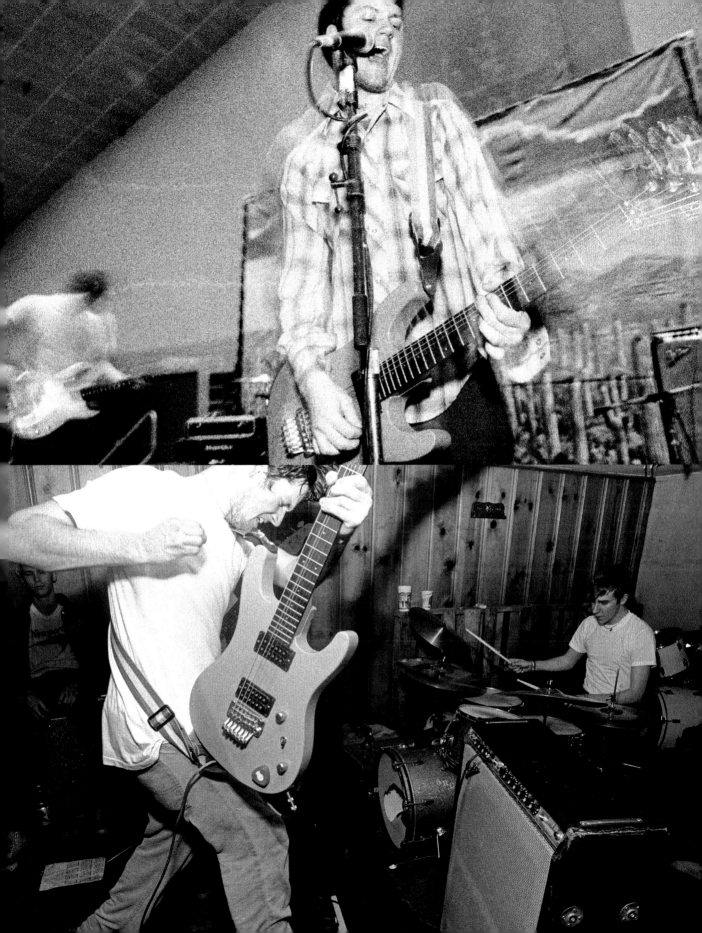

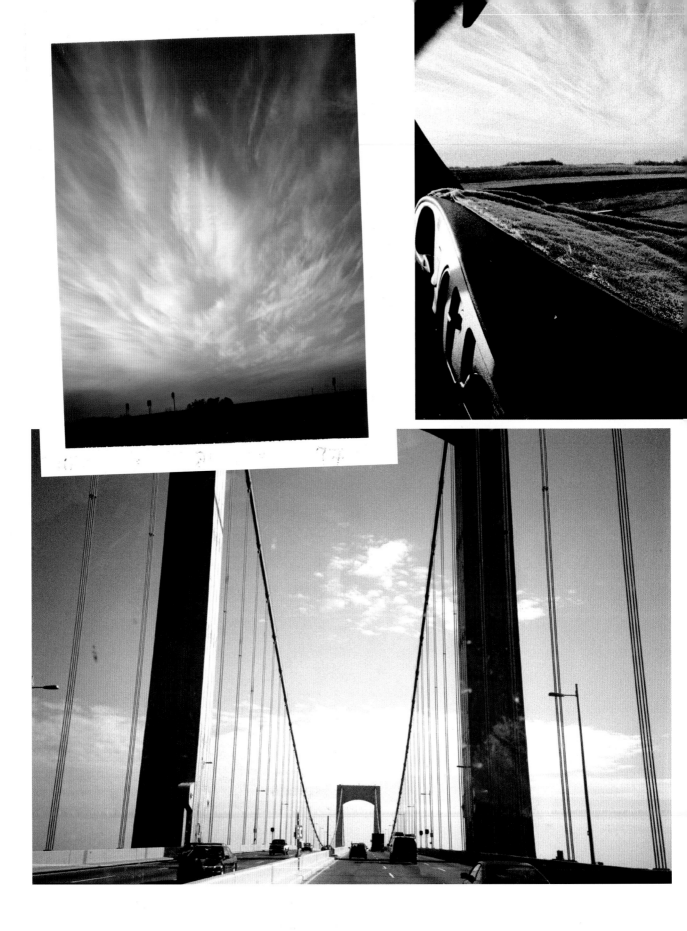

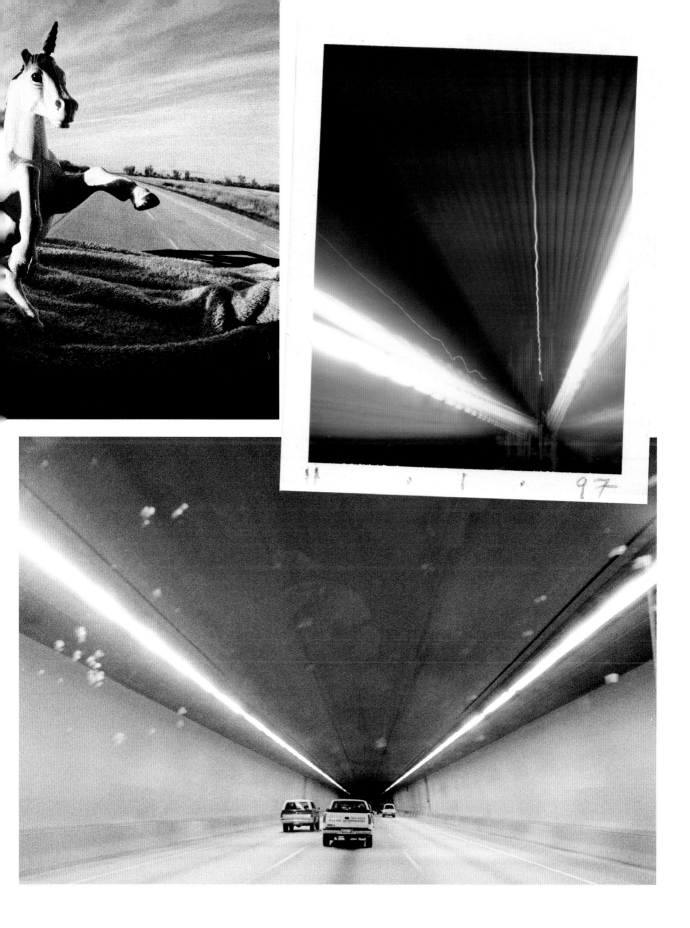

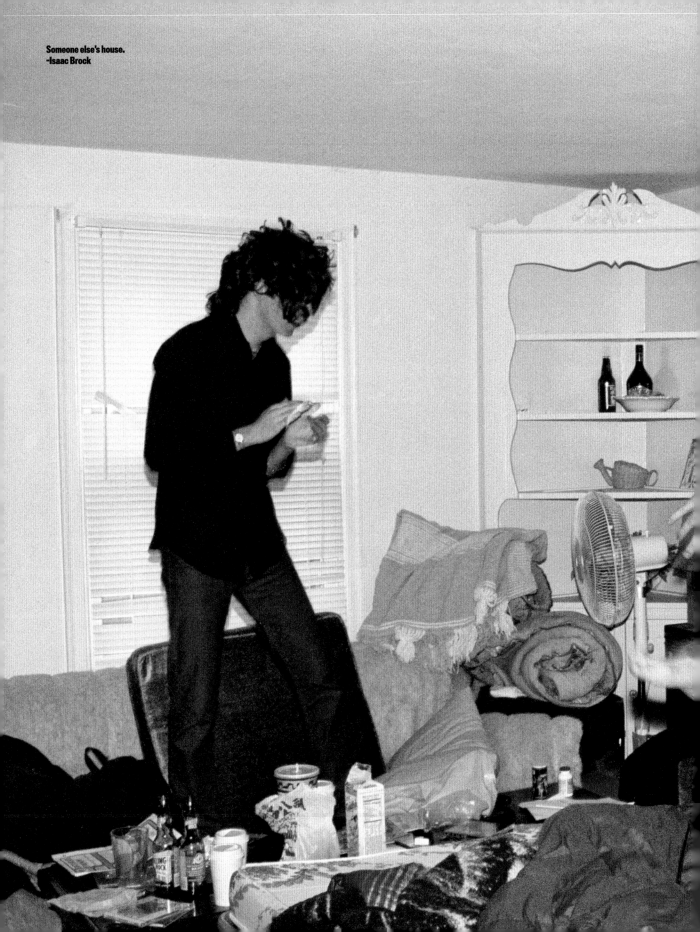

Someone else's house.
-Isaac Brock

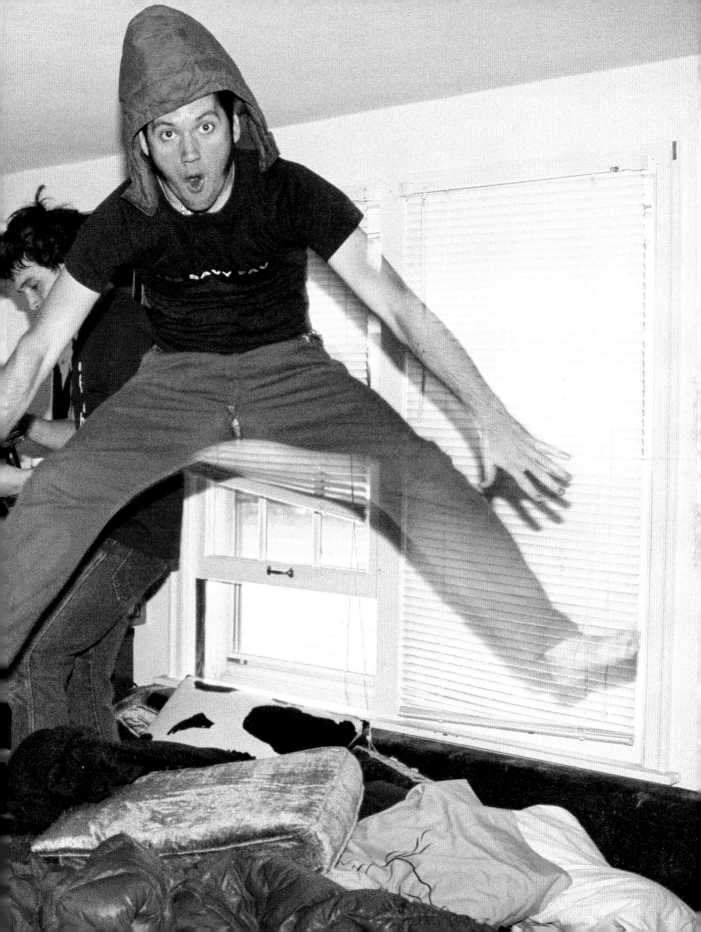

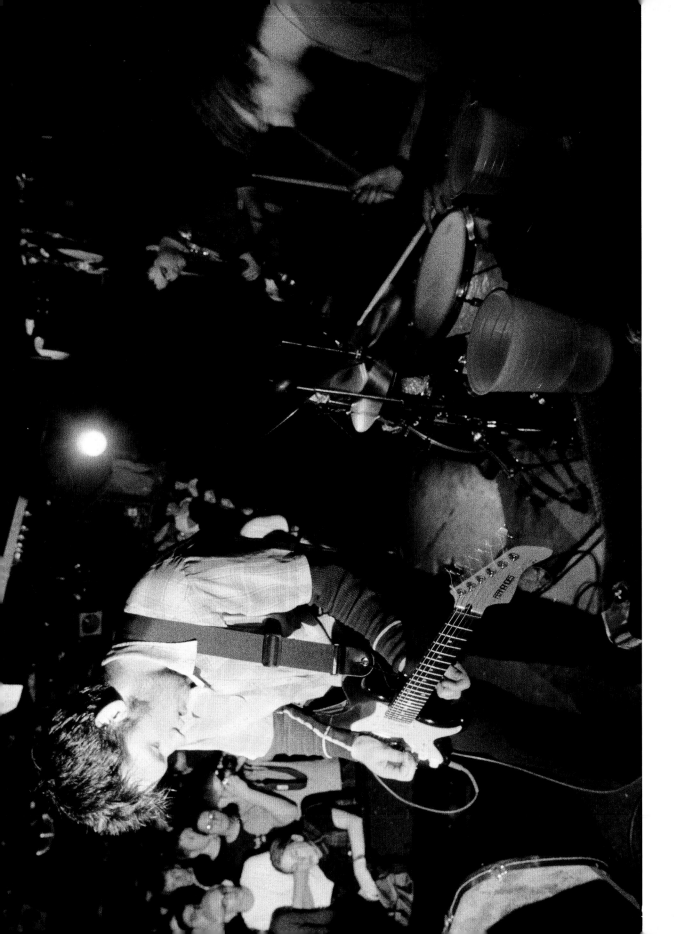

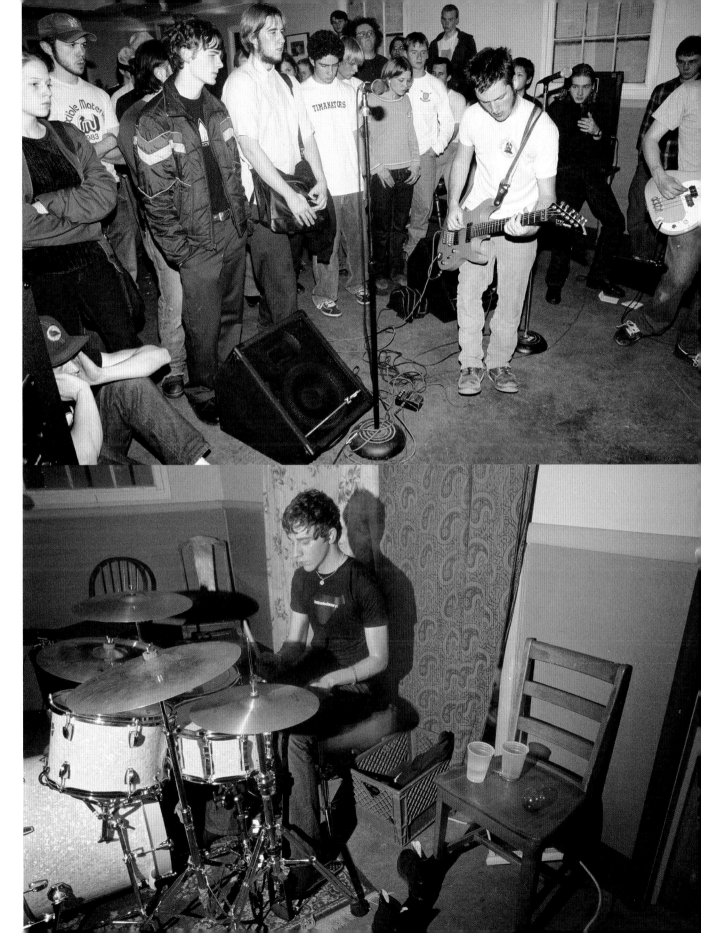

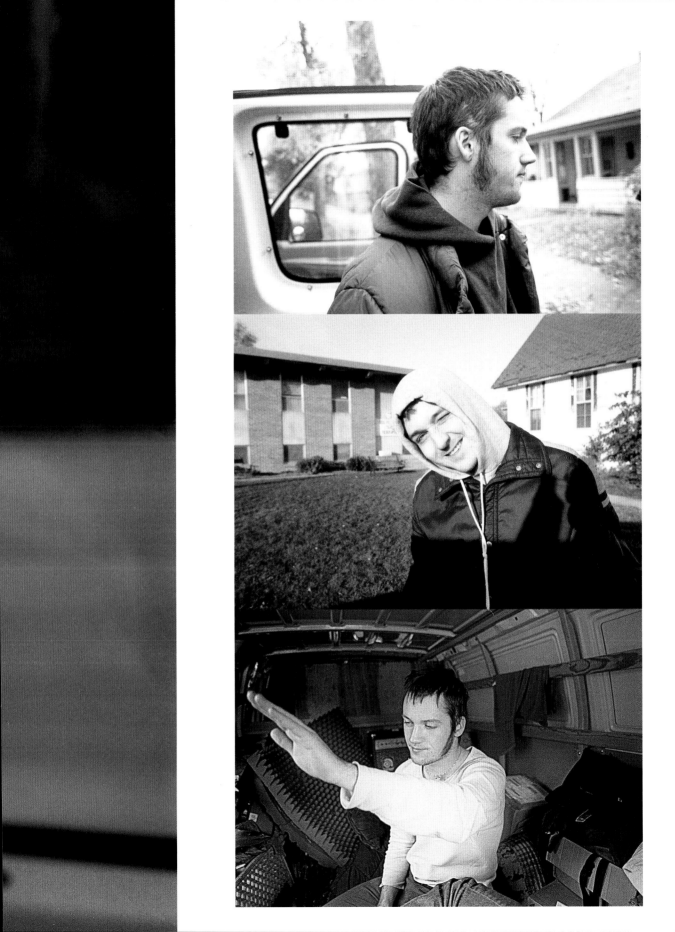

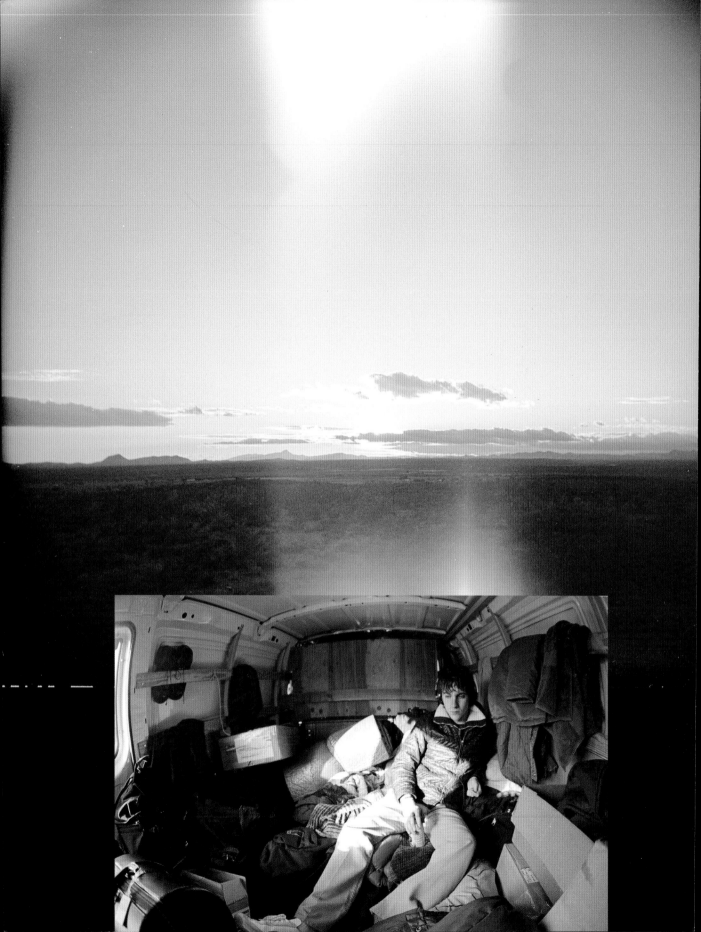

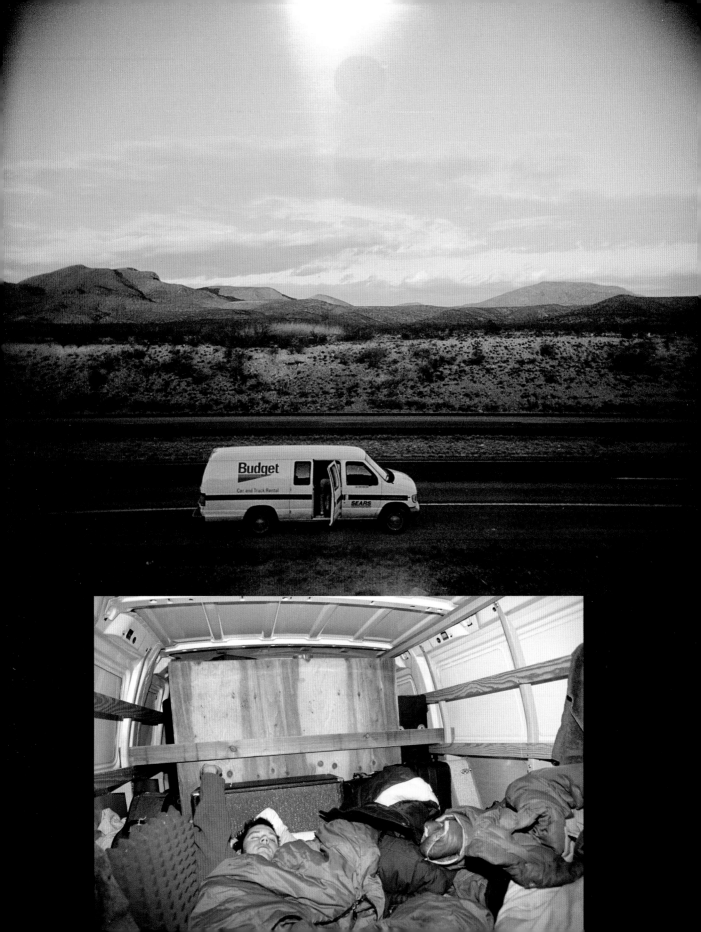

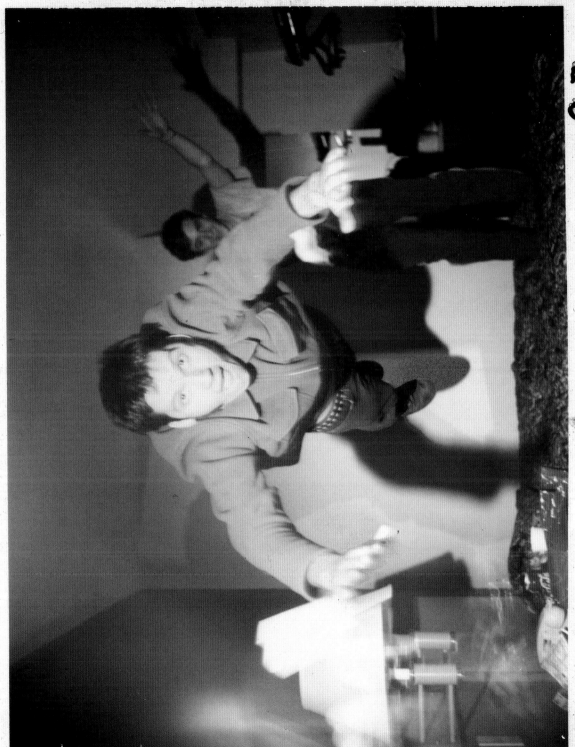

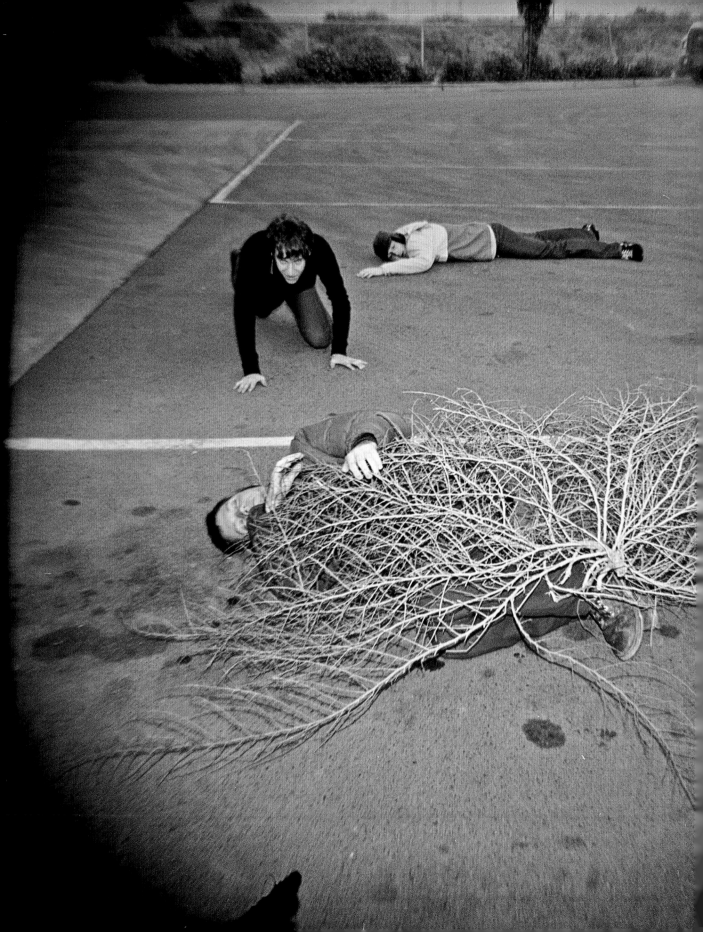

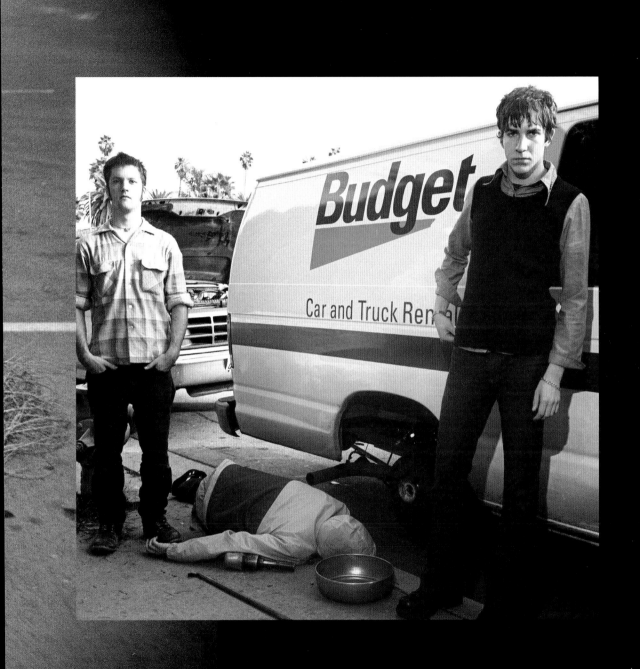

FALL 1997

For this tour Isaac decided to rent a Budget van. If the van broke down they would just give us another one. The only slight issue with the van was it was a cargo van. No seats, and a cage separating the driver from passengers. Basically we just threw all the equipment, luggage, and merch in the back, and we slept/sat within it.

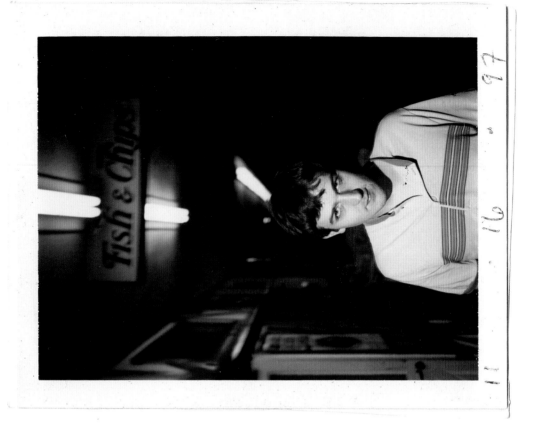
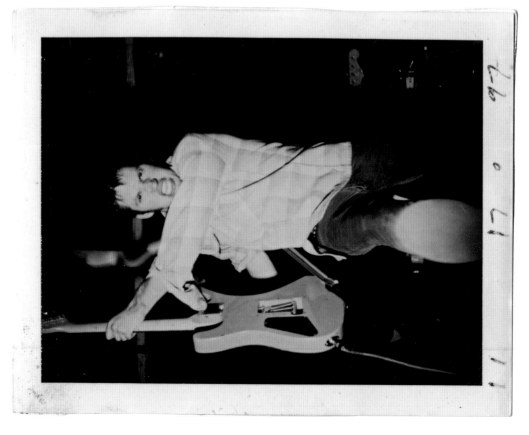

5 . 19 . 98

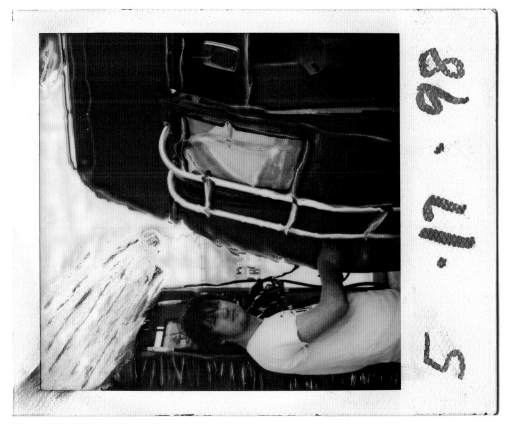

5 . 17 . 98

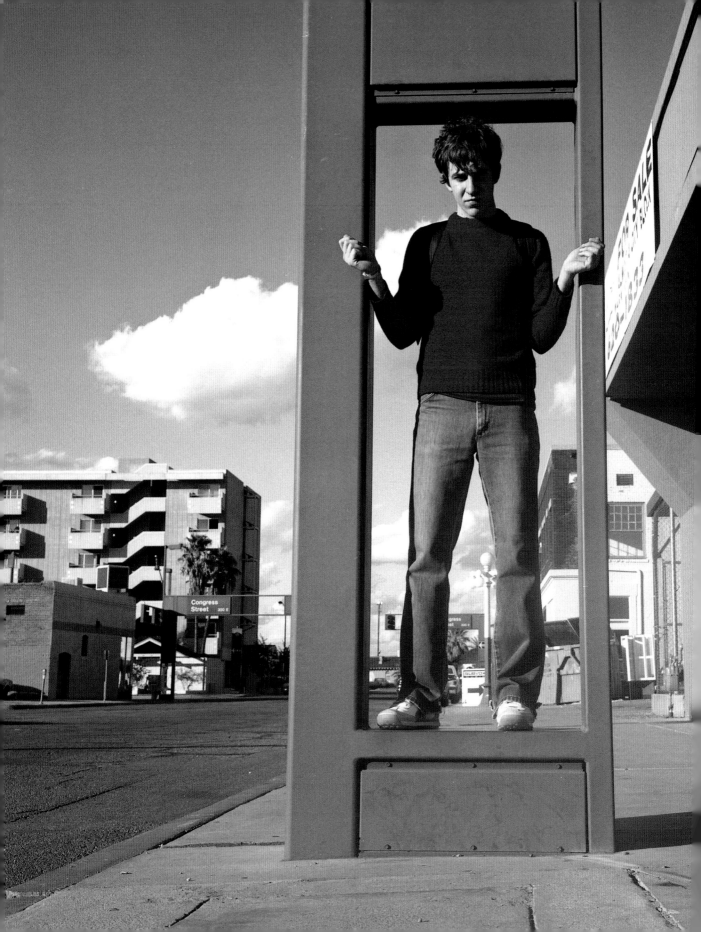

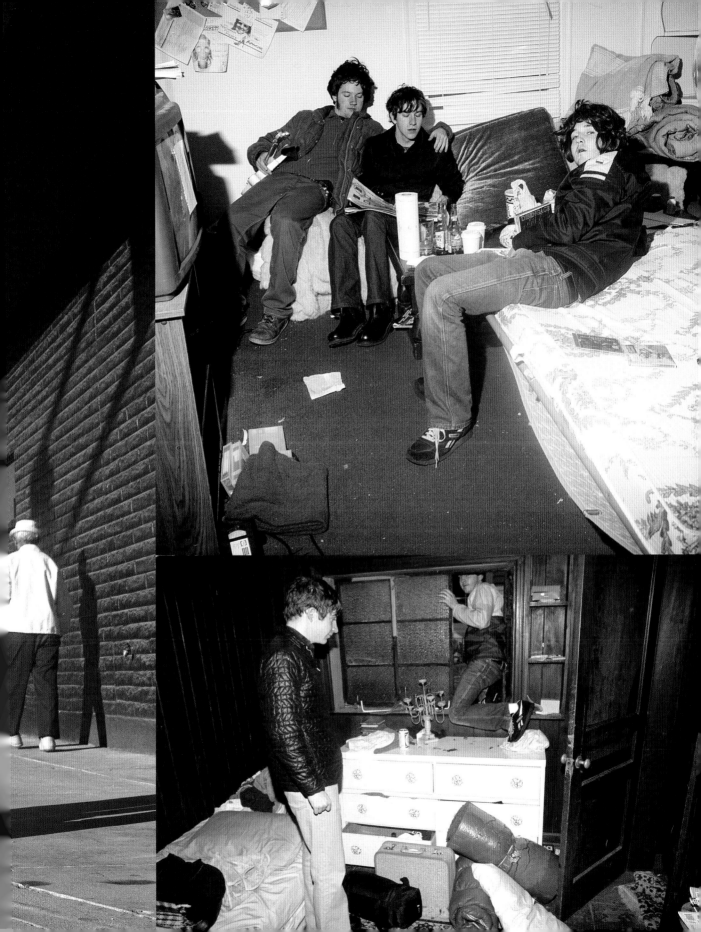

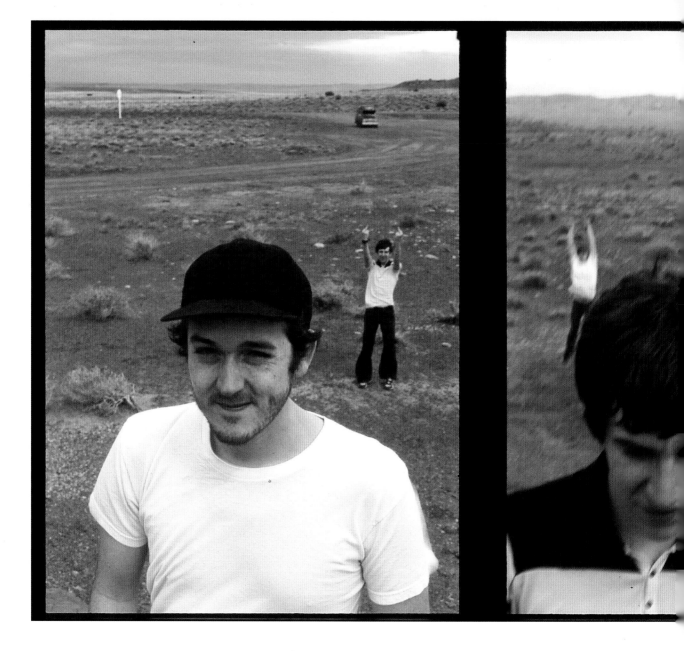

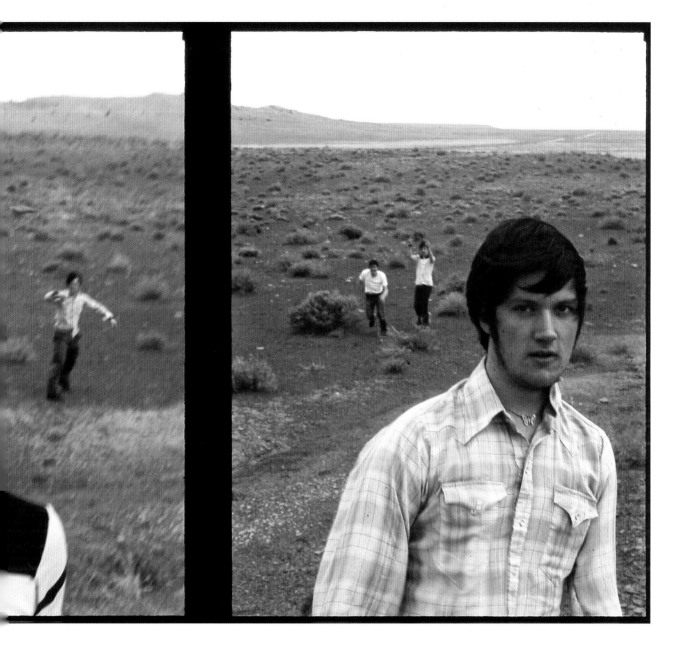

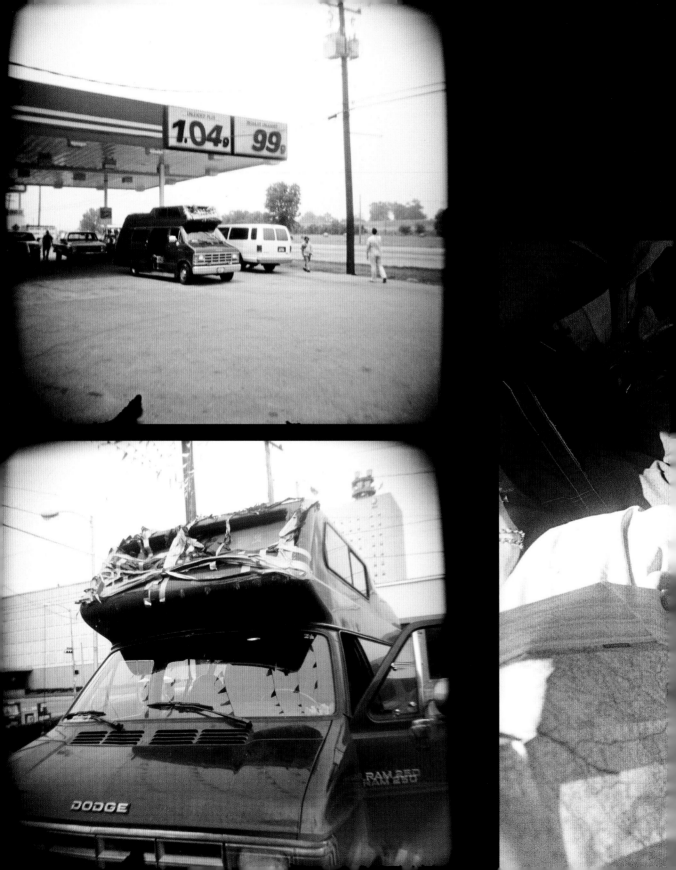

1999: THE YEAR OF THE VANSION

The ultimate touring vehicle, double height and length,
lots of room to spread out.

I particularly liked the top of the Vansion as it had a
window to look out and photograph from. The window
was great but it did get smashed once in Canada by a
low hanging sign. After rummaging around we found
some sheet metal and a load of duct tape to take the
place of the smashed window.

This worked well until it all became shredded after
driving hundreds of miles at top speeds. After that,
lying in the top of the top of the vansion was like riding
on the wing of a plane.

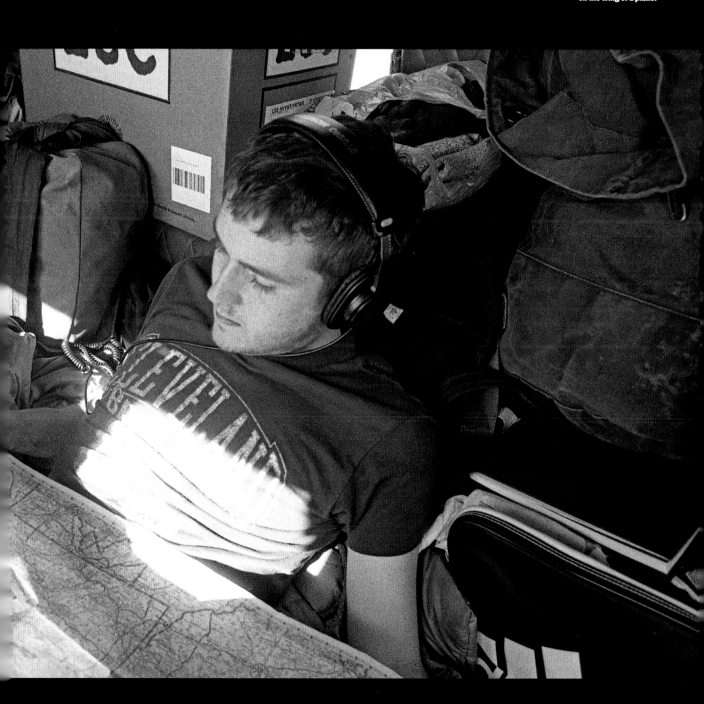

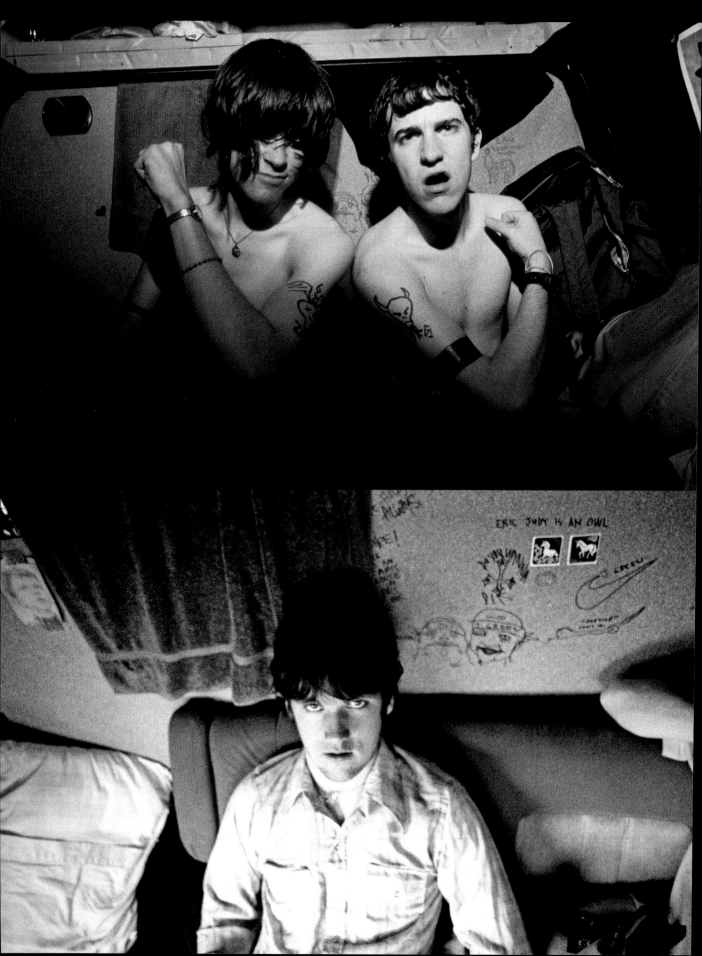

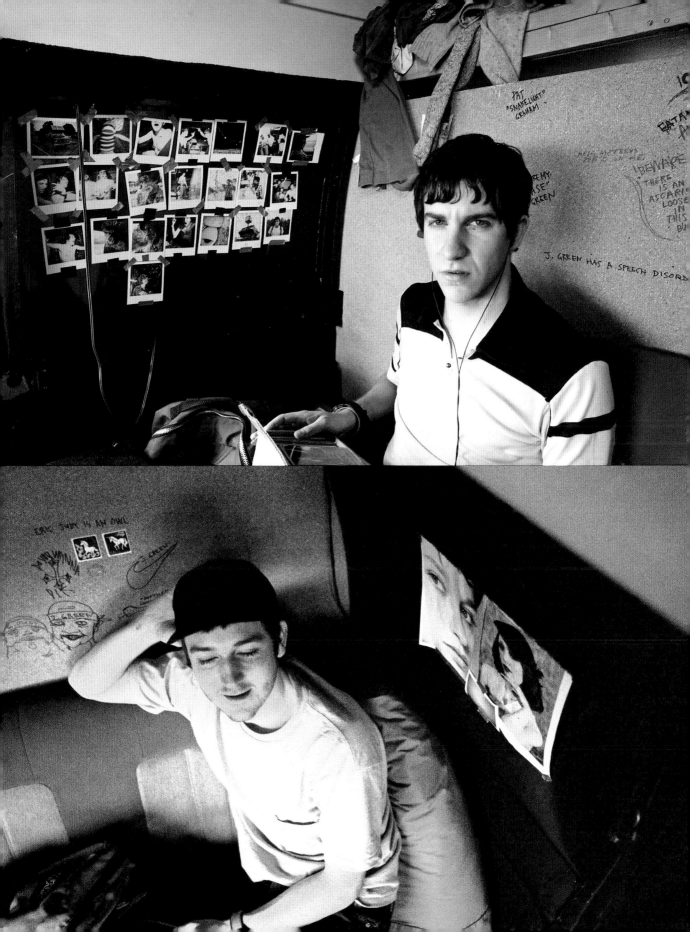

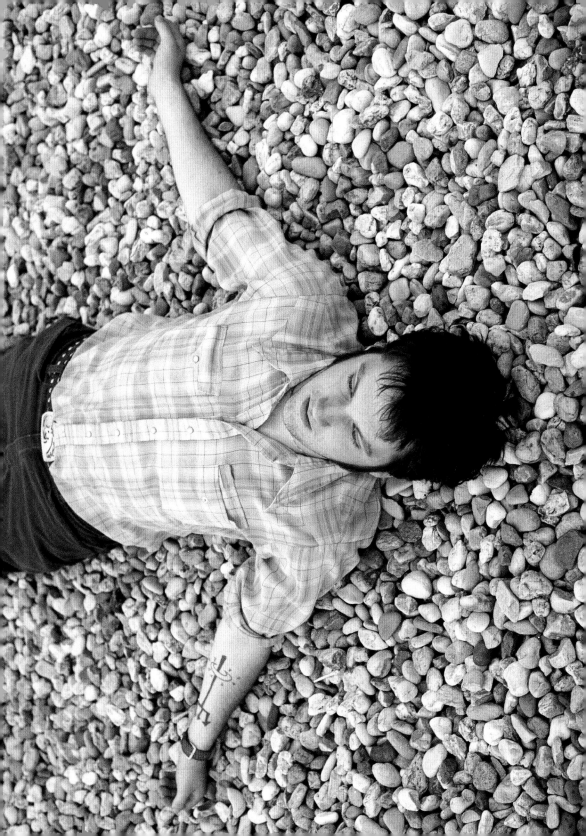

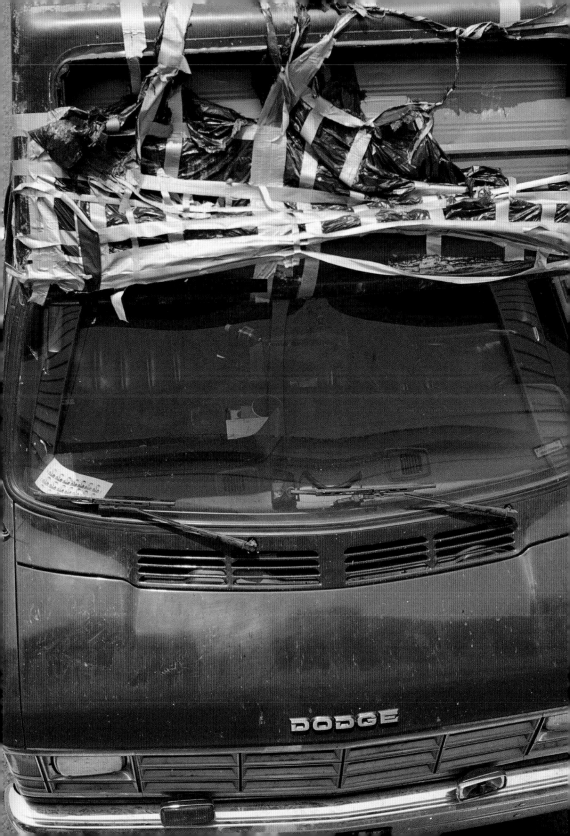

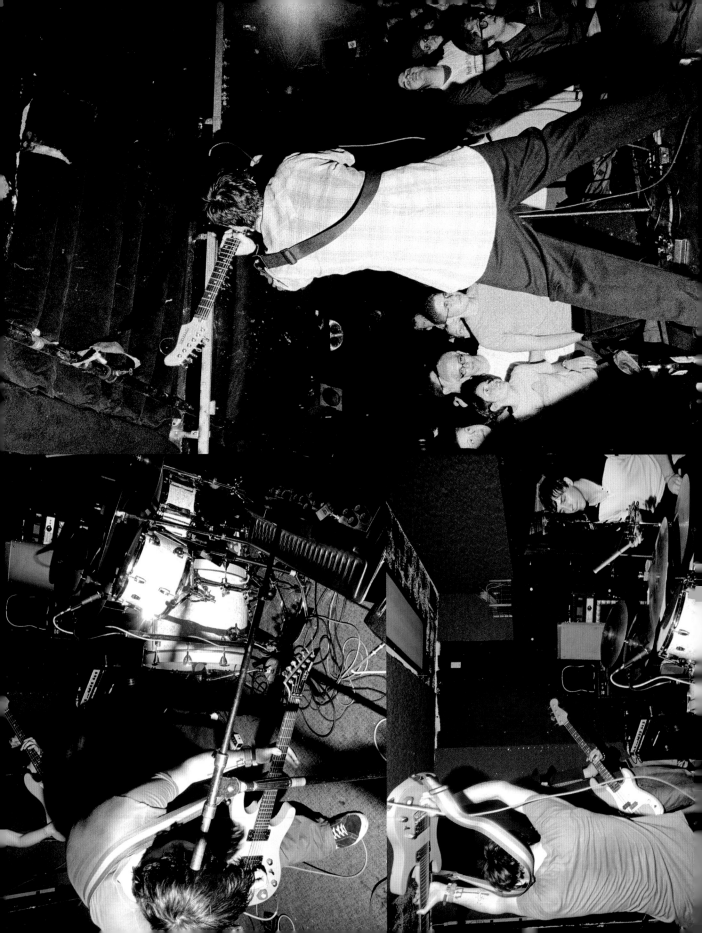

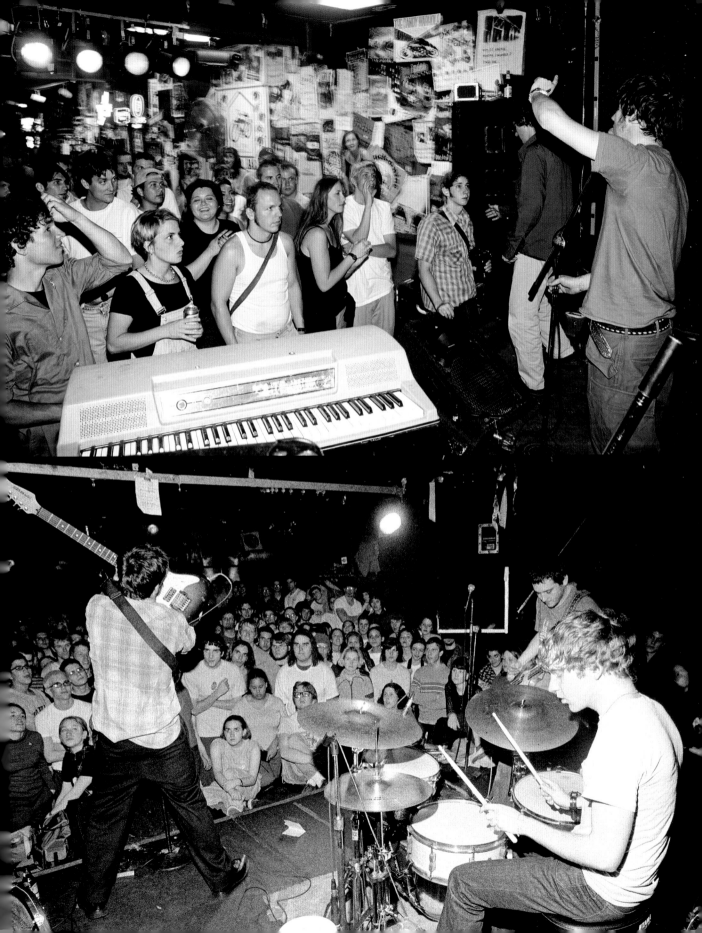

These are some of the SX-70 Polaroid's I shot on the 1999 tour. Since 1997 I had been shooting at least one Polaroid a day. I would tape up our favorites in the van, on the back walls (see page 29). I like the idea that these Polaroids made the journey with us, and this shows their physical condition.

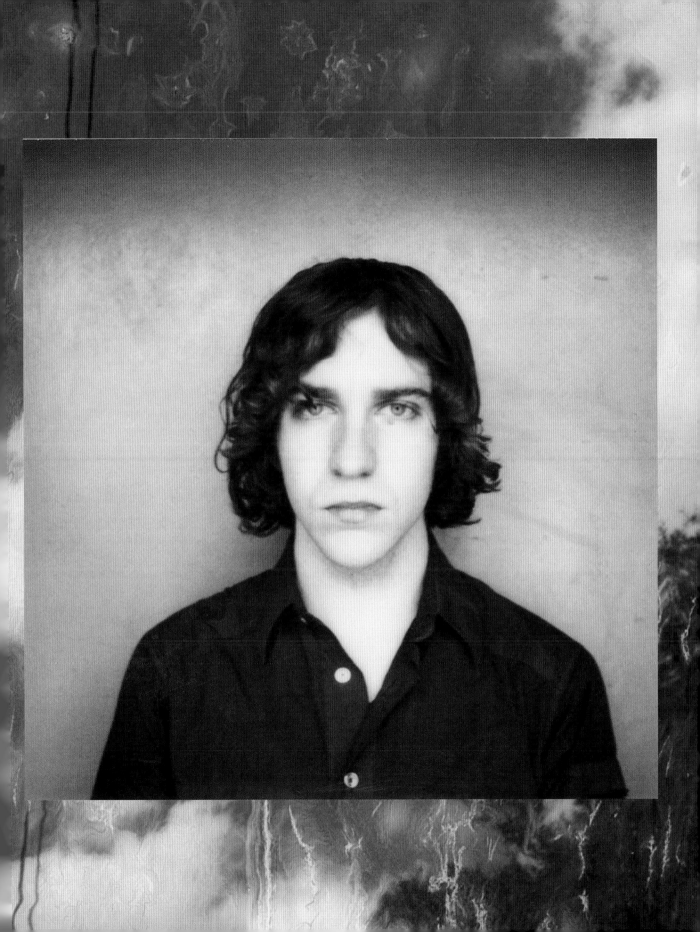

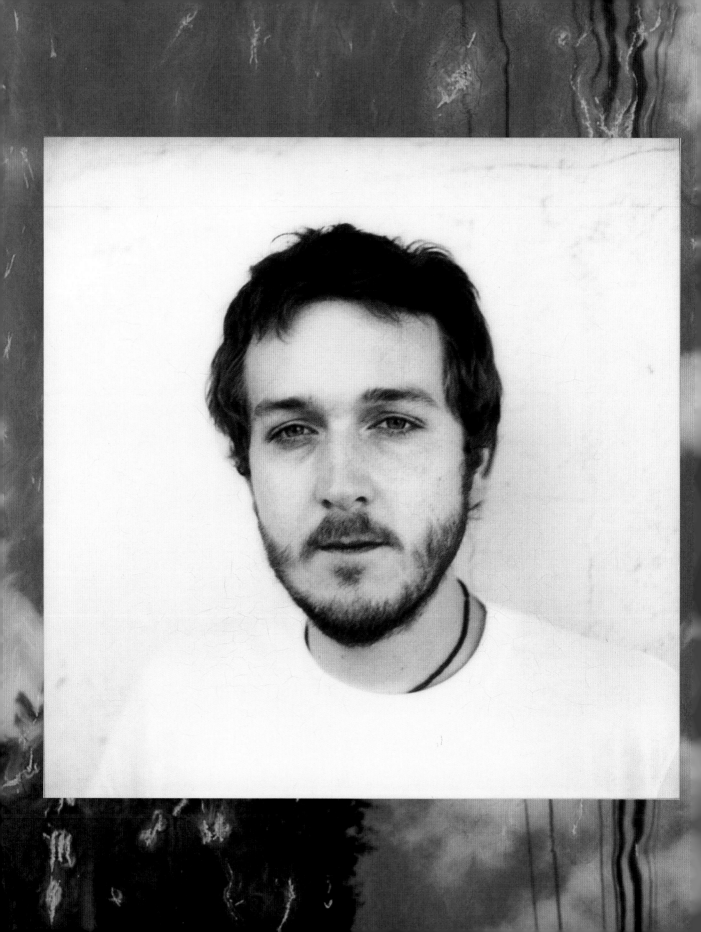

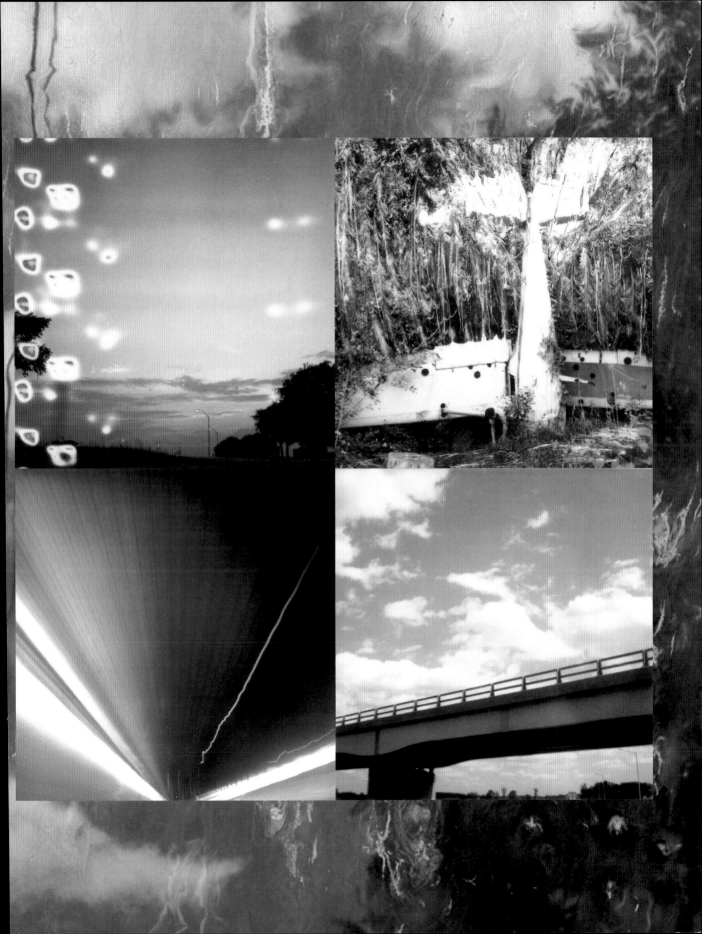

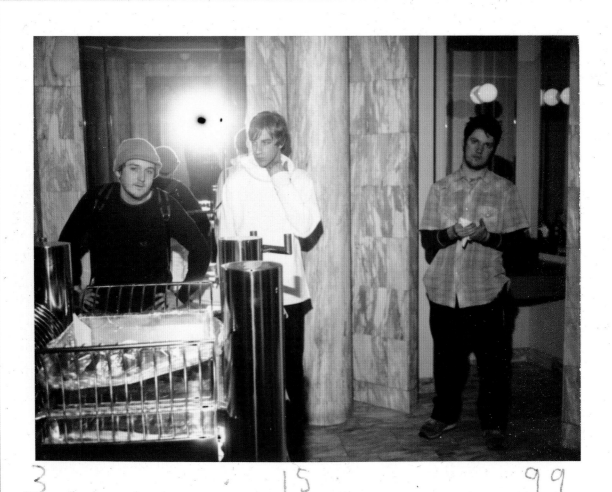

3 15 99

We had some time in N.Y.C. and our friend Syd Butler invited
us to a heavy metal night at the Windows on the World bar,
which was at the top of the twin towers.

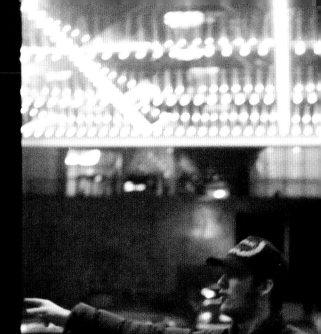

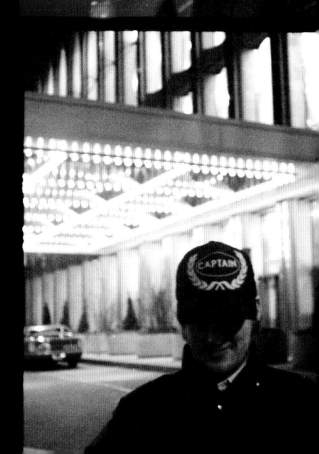

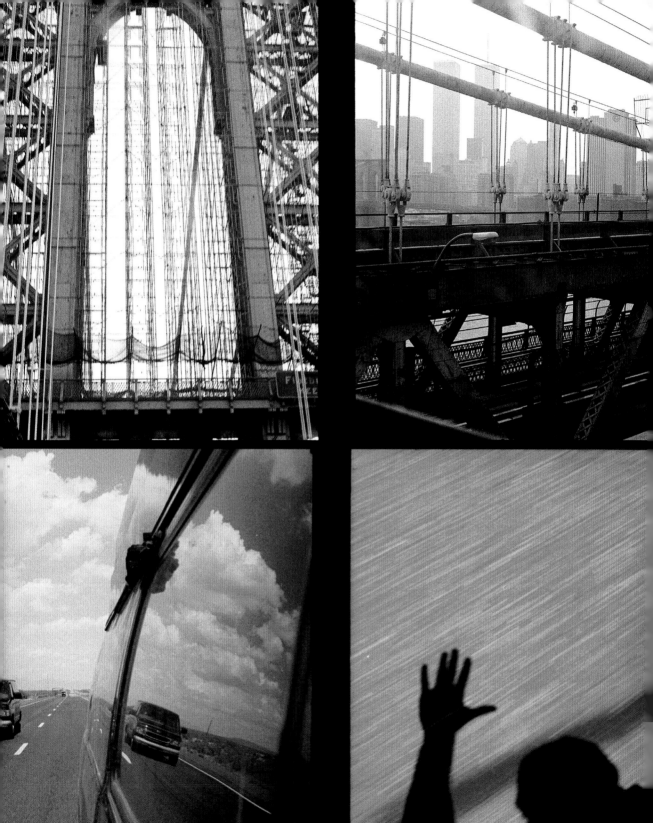

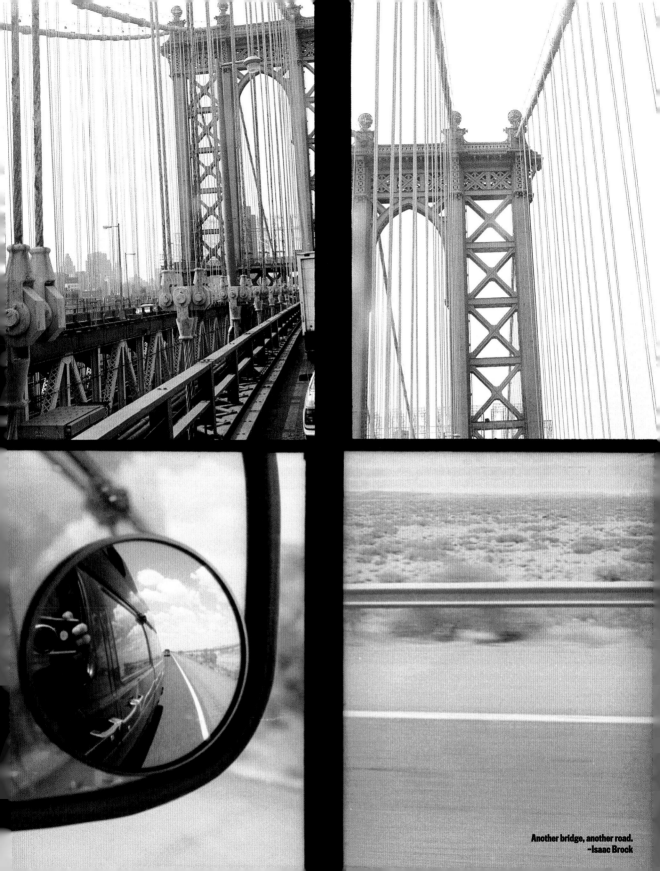

Another bridge, another road.
—Isaac Brock

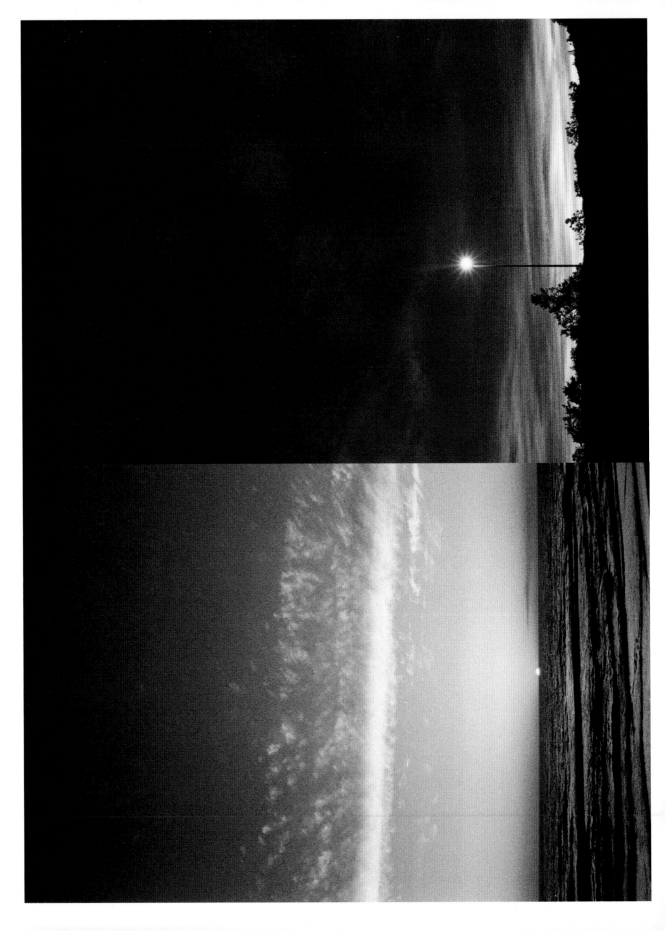

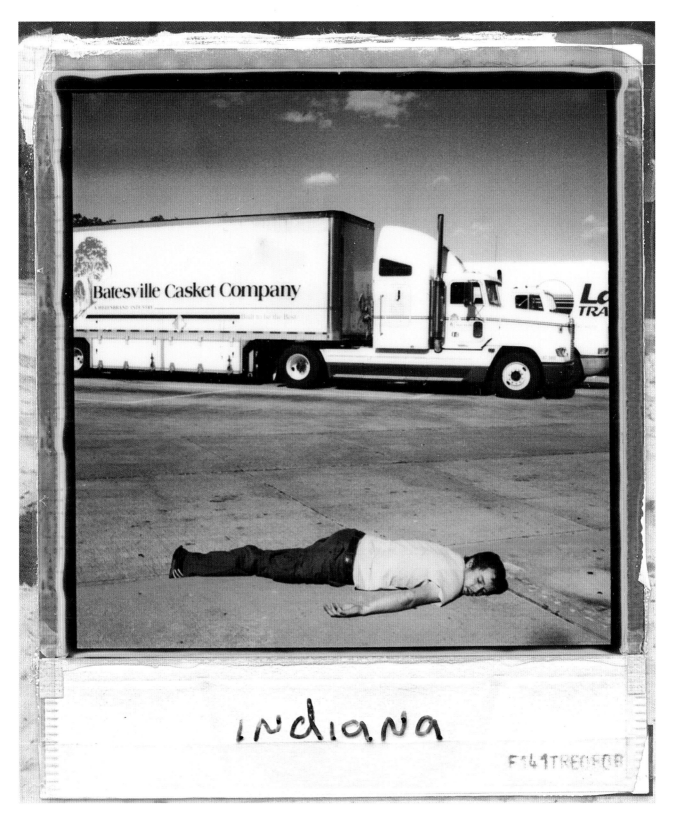

INDIANA

I don't remember what happened, but it looks to me like a terrible accident in Indiana.
—Eric Judy

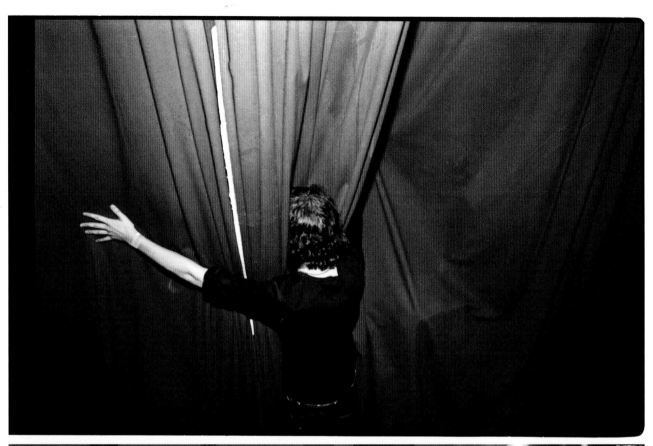

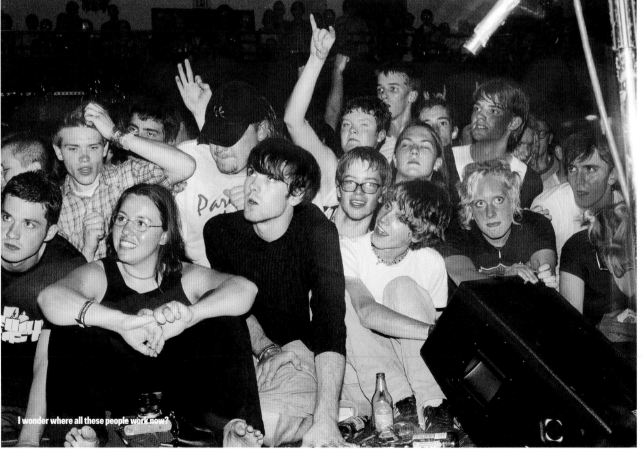

I wonder where all these people work now?

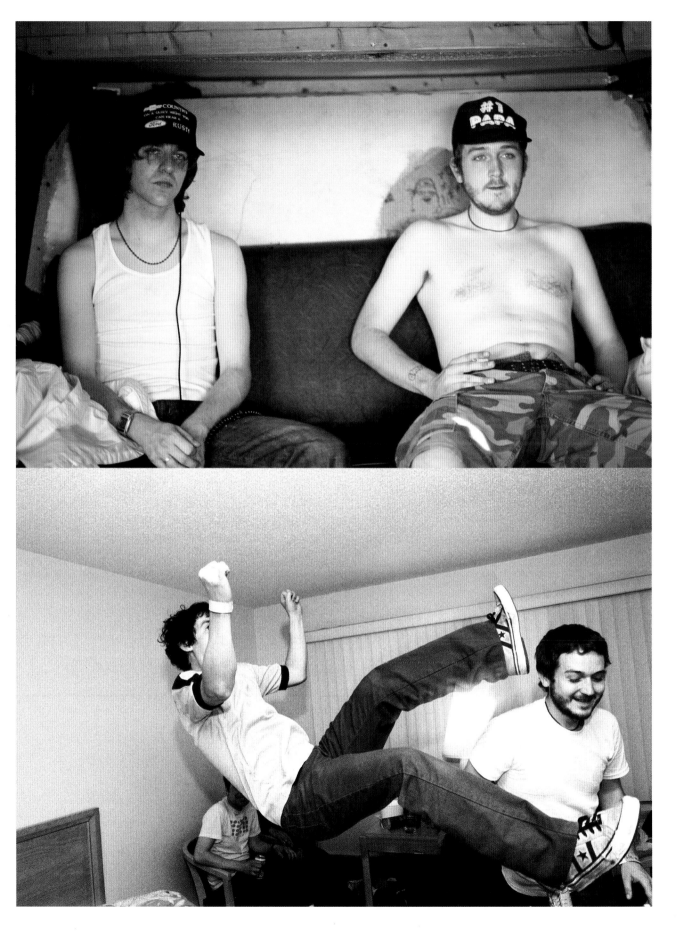

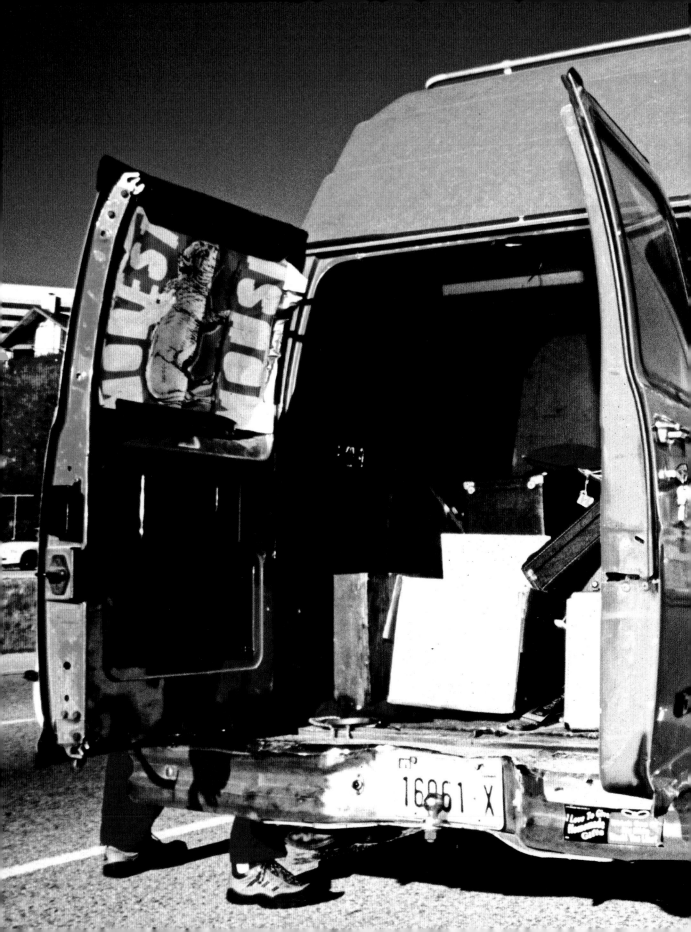

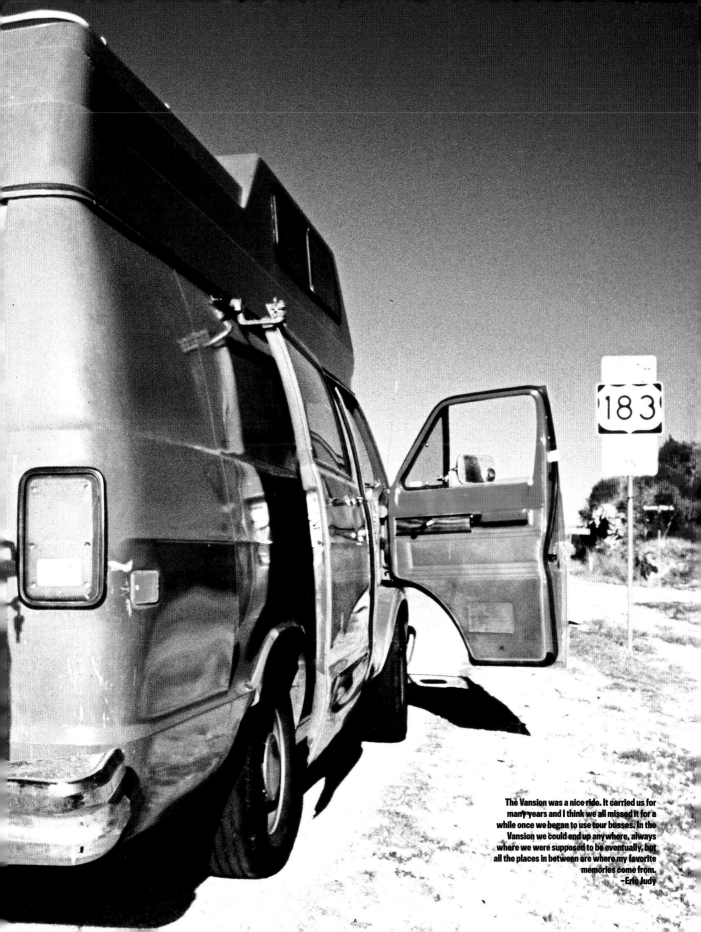

The Vansion was a nice ride. It carried us for
many years and I think we all missed it for a
while once we began to use tour busses. In the
Vansion we could end up anywhere, always
where we were supposed to be eventually, but
all the places in between are where my favorite
memories come from.
–Eric Judy

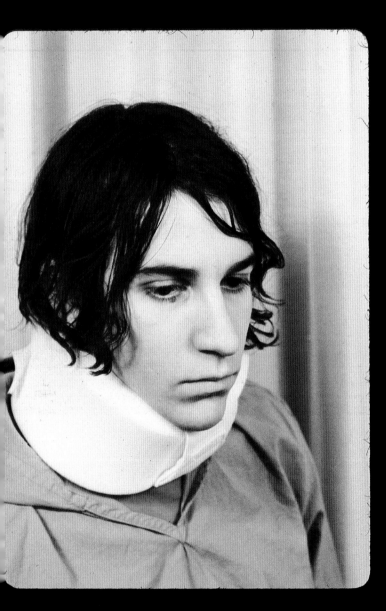
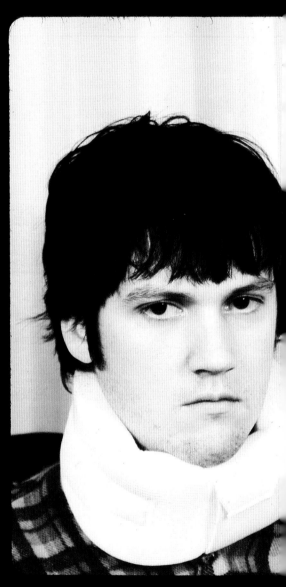

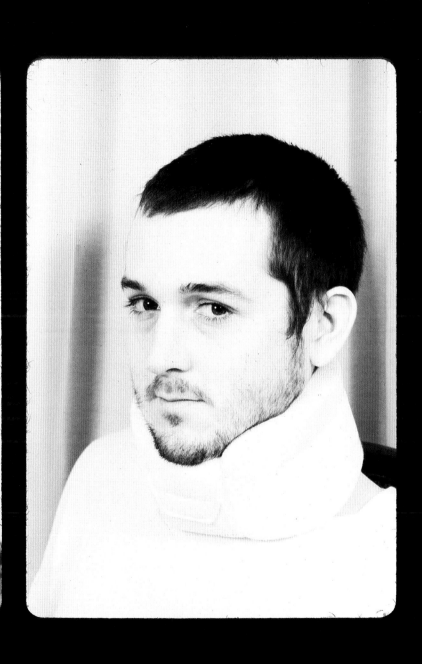

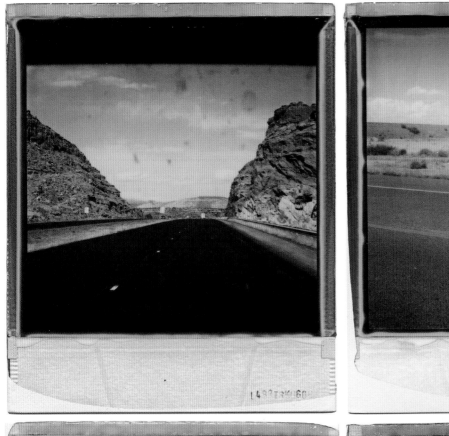

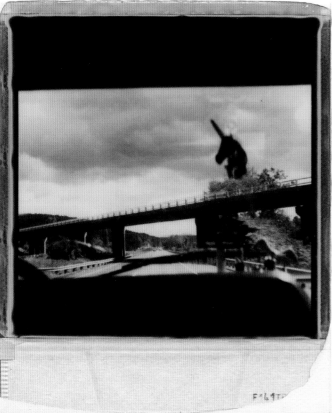

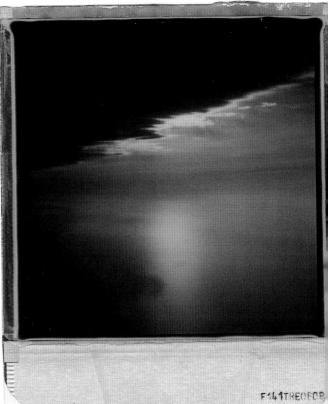

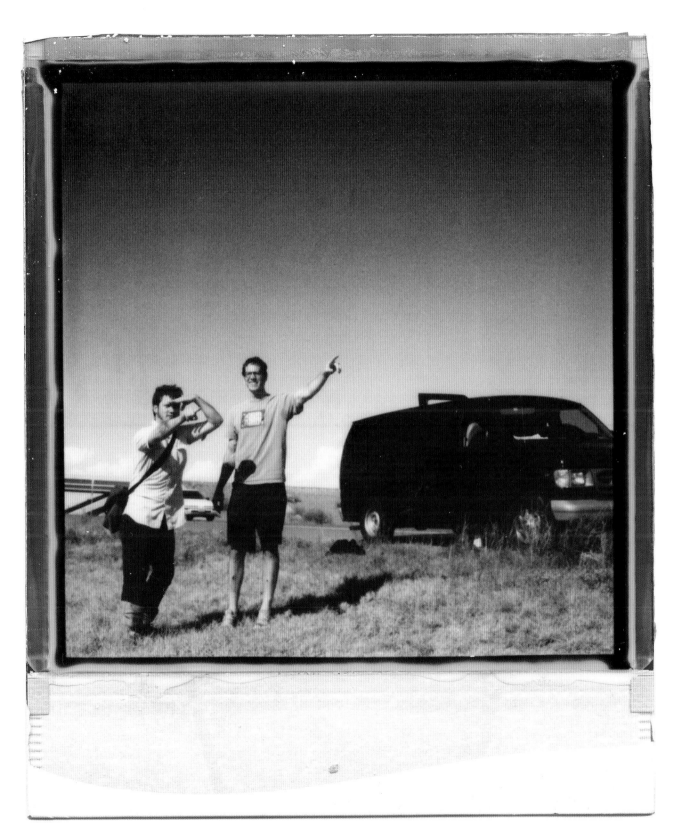

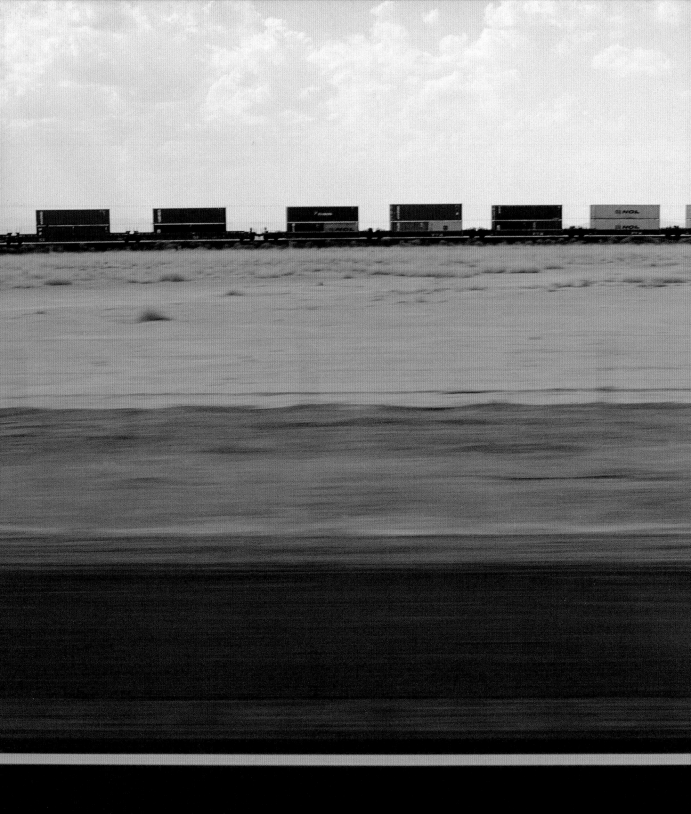

By 2000 the band had grown in members and crew. We now traveled in two vans: the Vansion for people, and Black Beauty for merch and gear.

The band's popularity continued to grow as the shows became larger. Isaac still made a point to stop if we wanted to see something or go in search of things on the road. I witnessed and photographed some of the most beautiful sunsets I had ever seen on that tour.

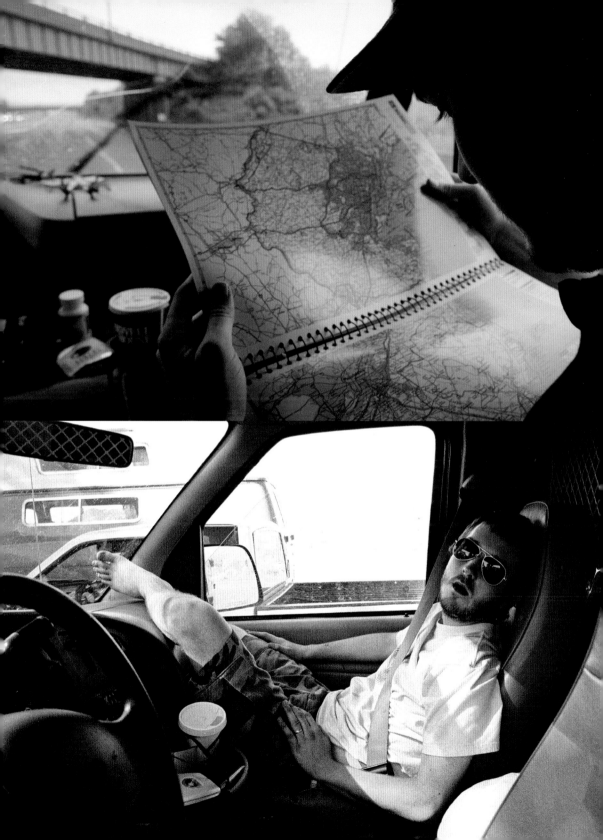

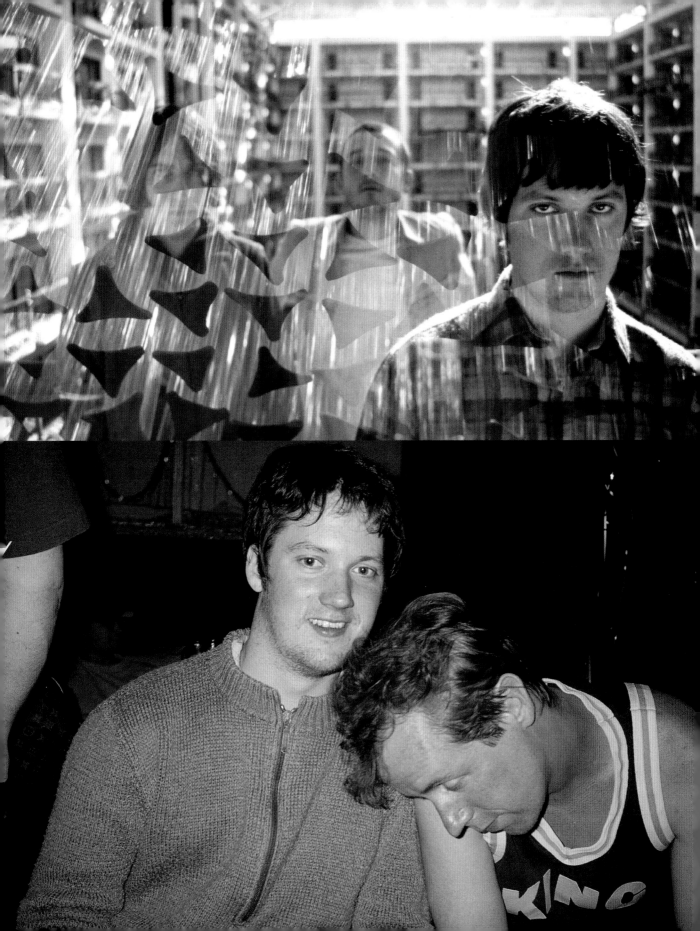

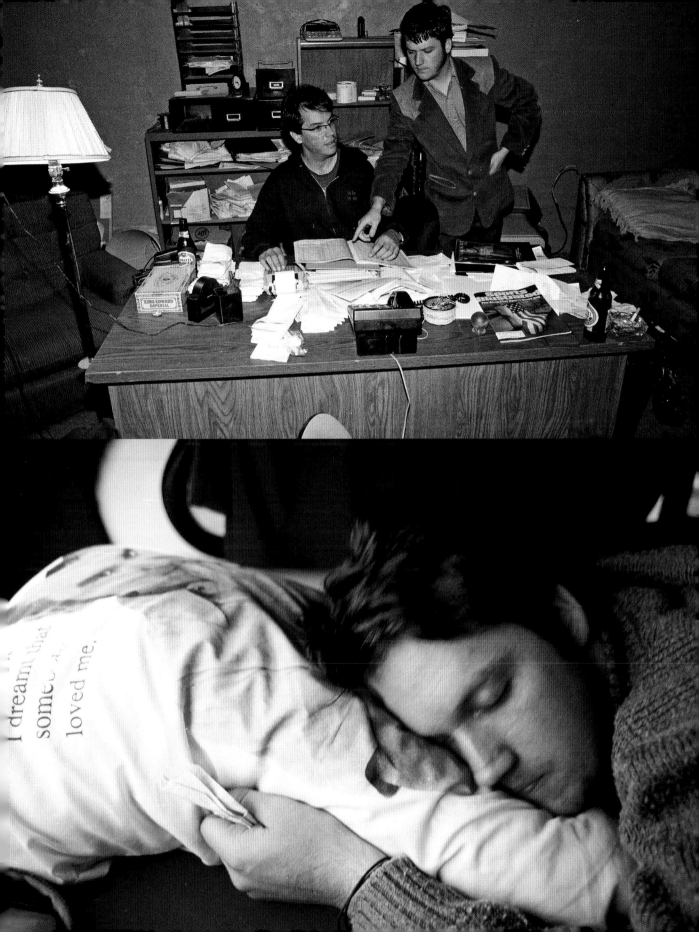

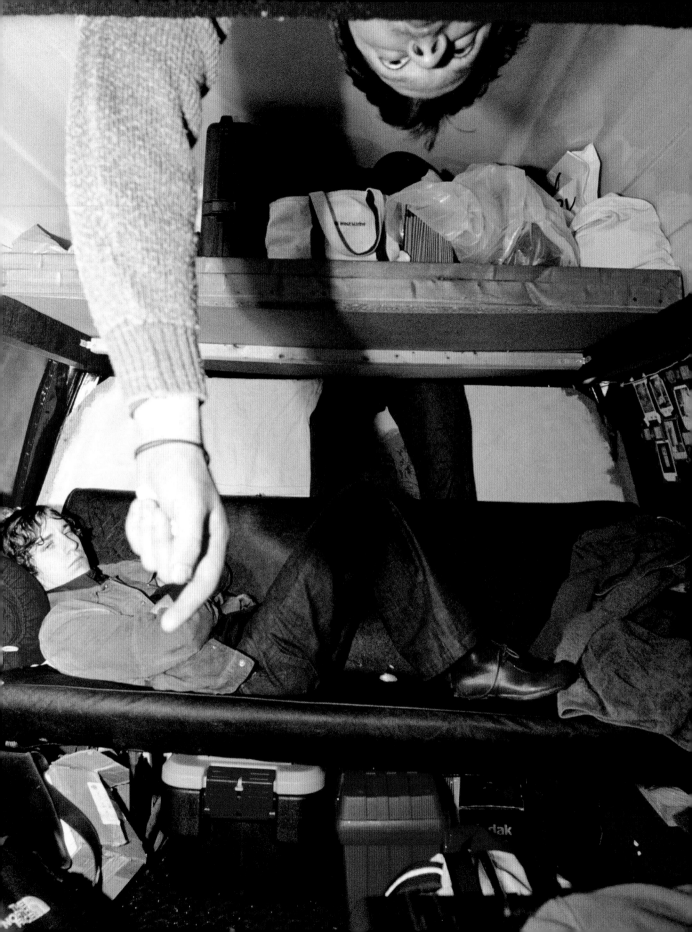

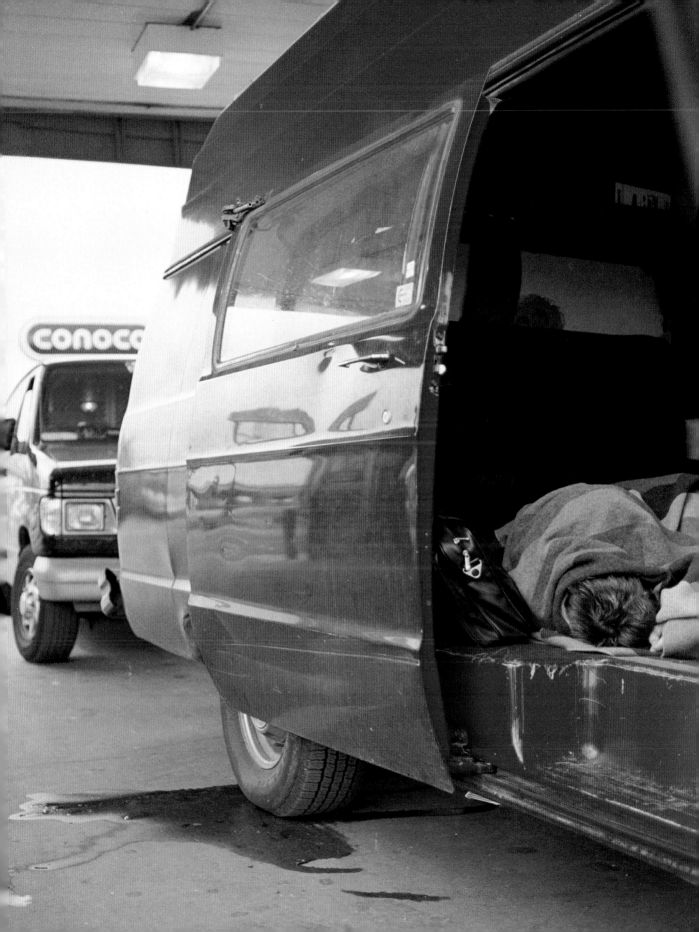

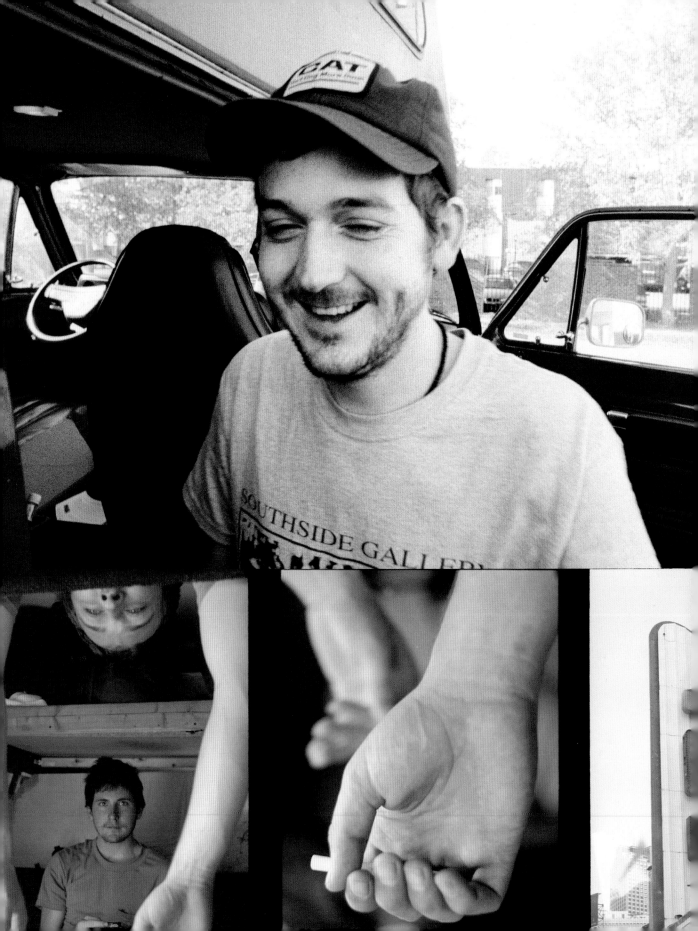

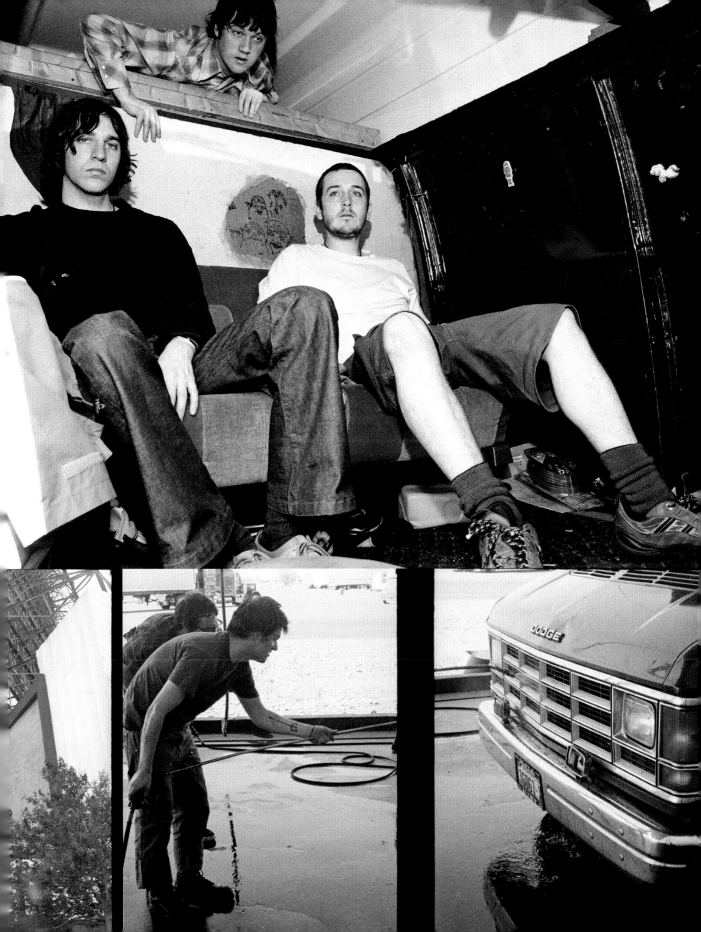

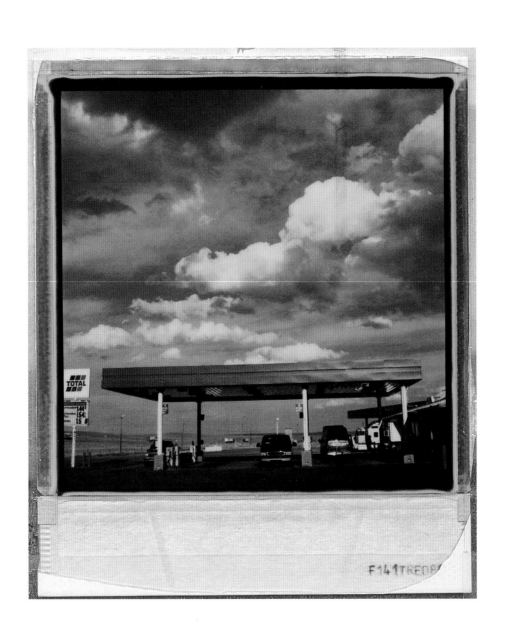

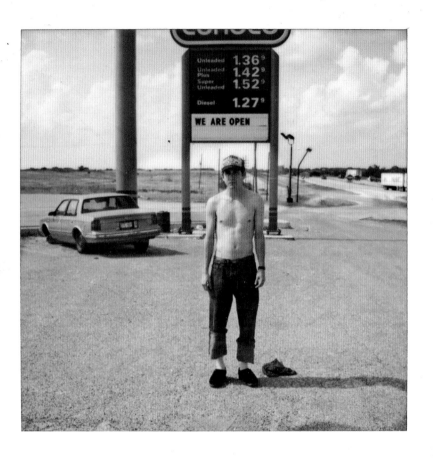

6·2·00 TEXAS

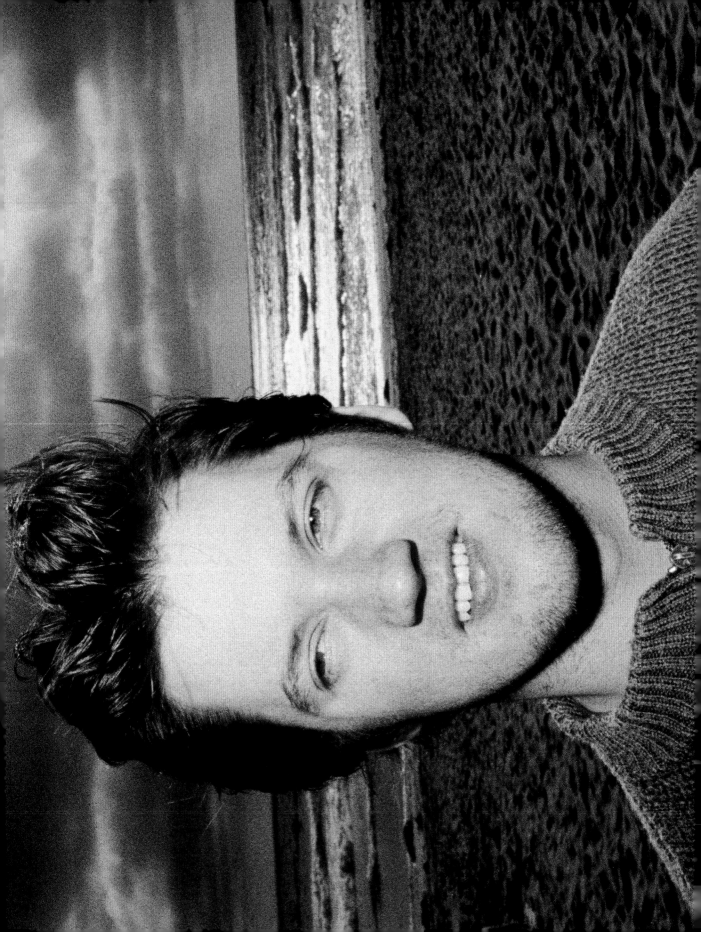

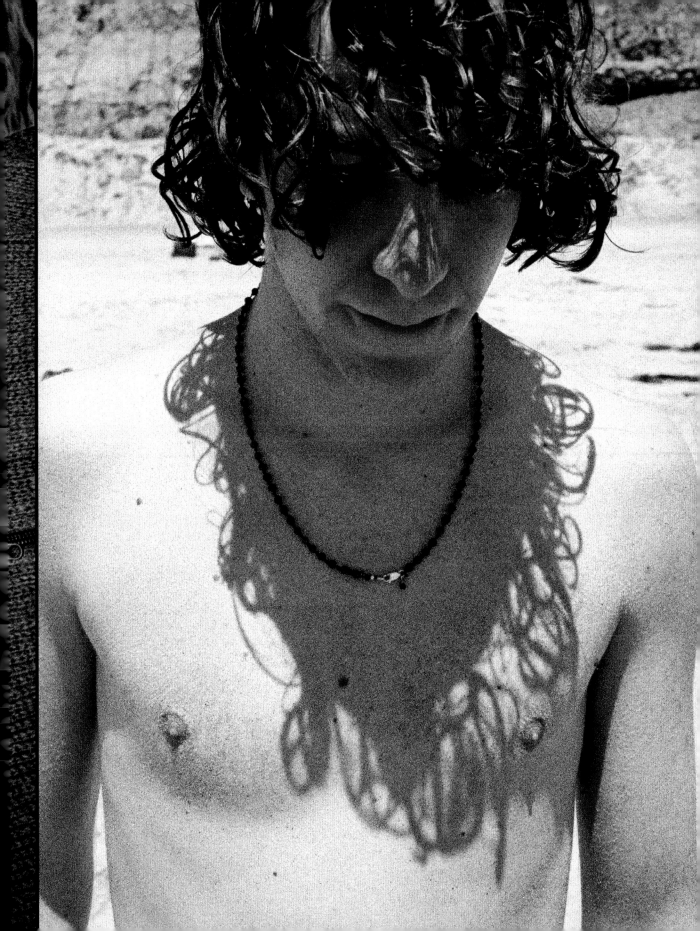

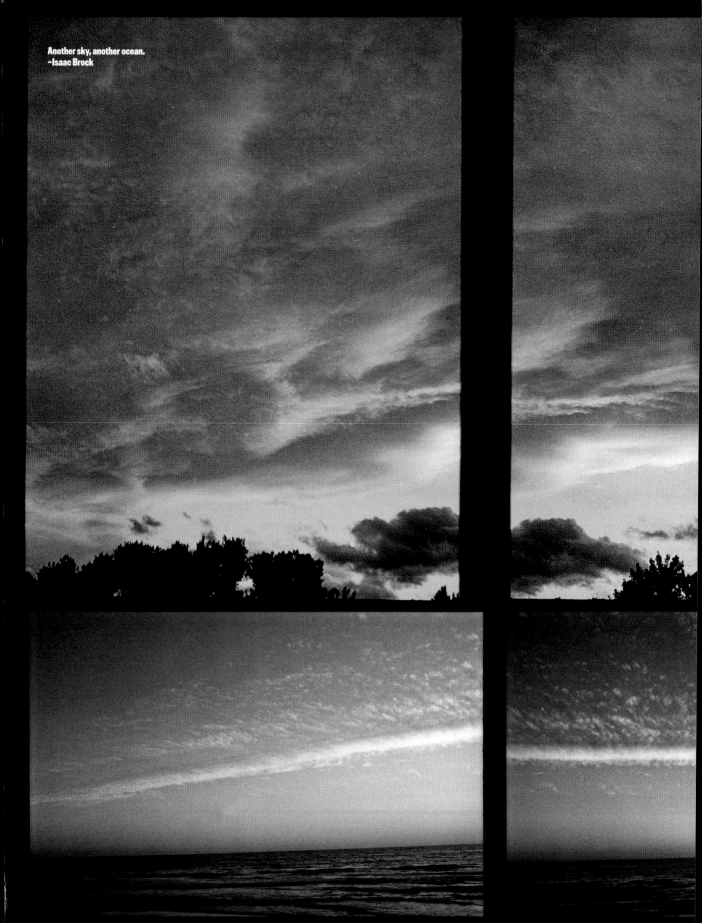

Another sky, another ocean.
-Isaac Brock

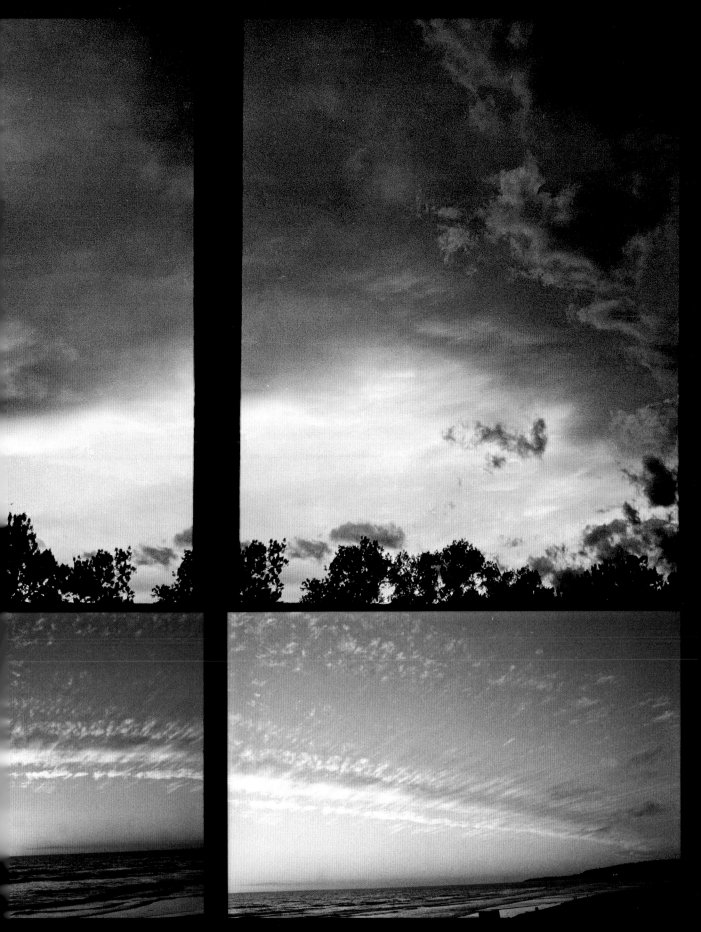

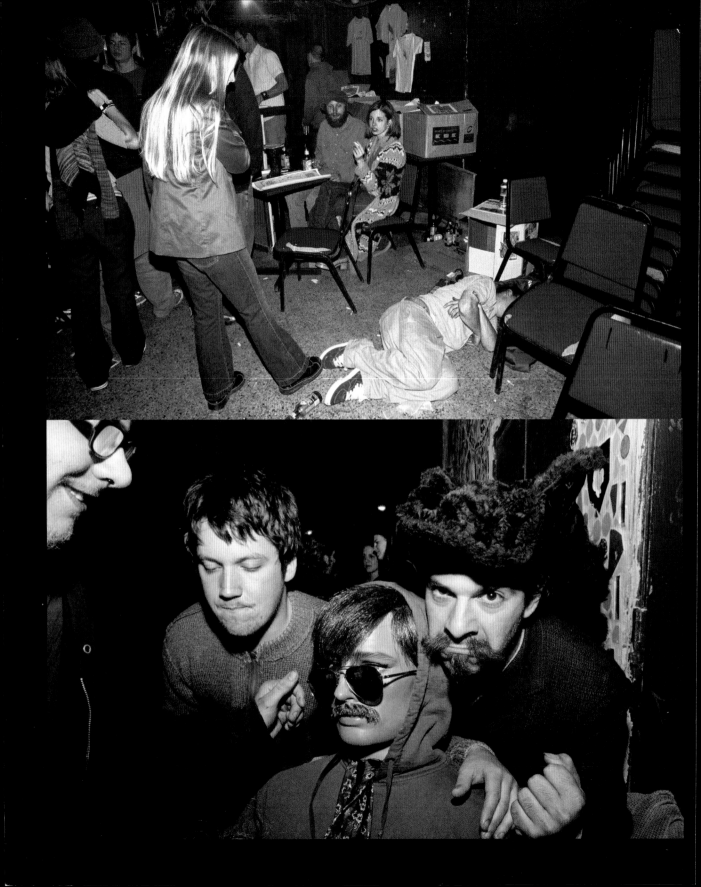

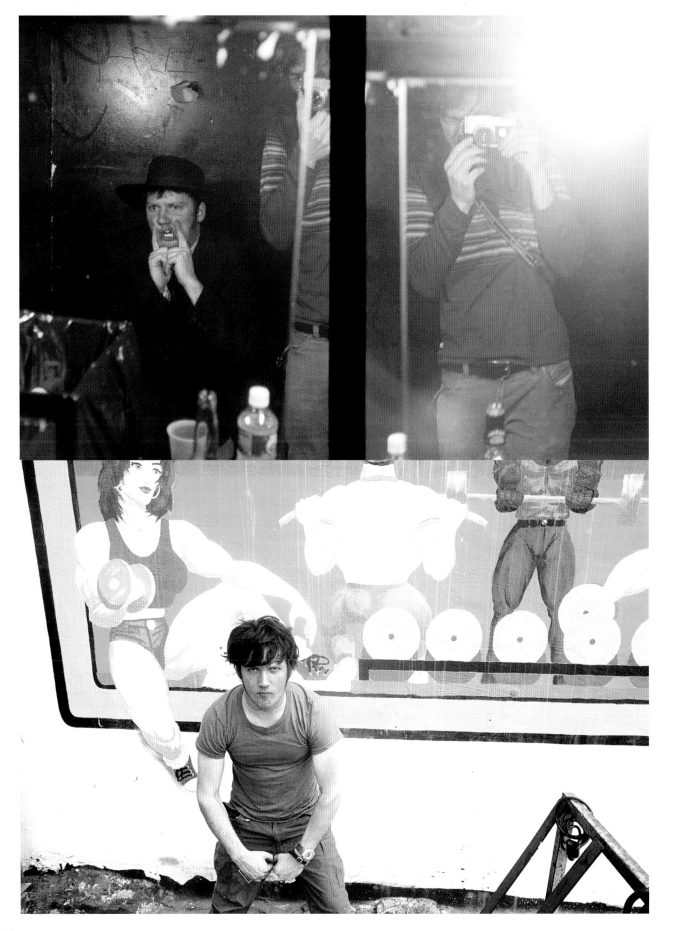

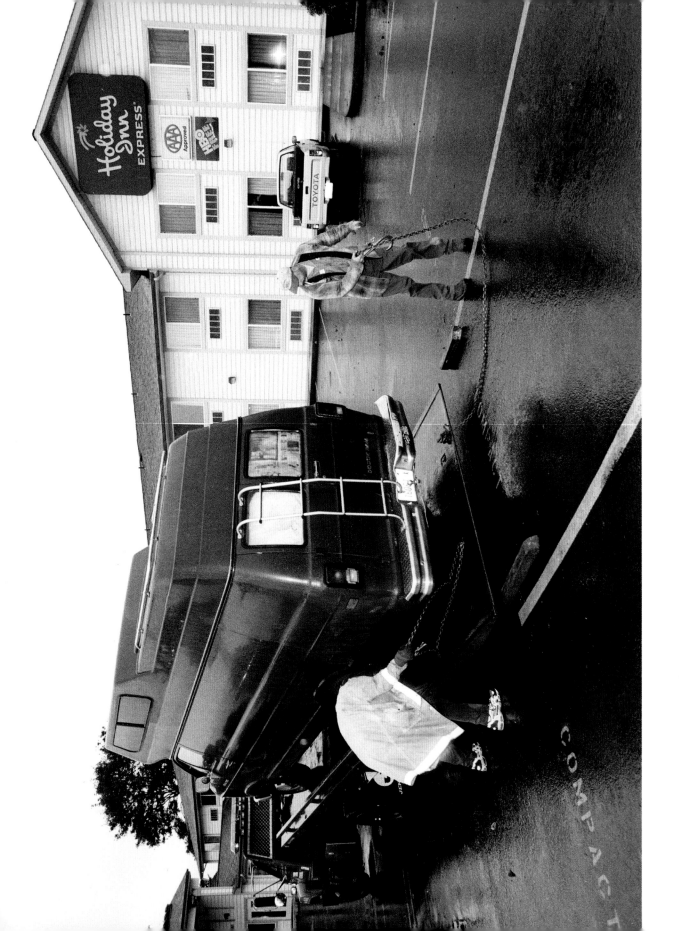

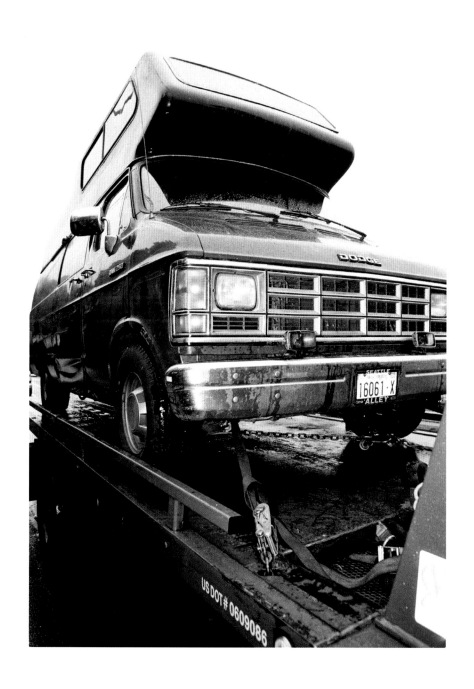

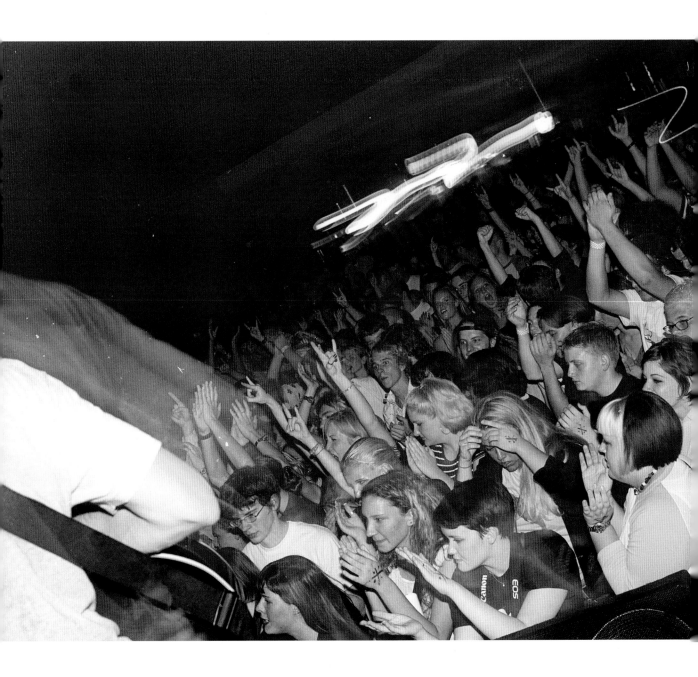

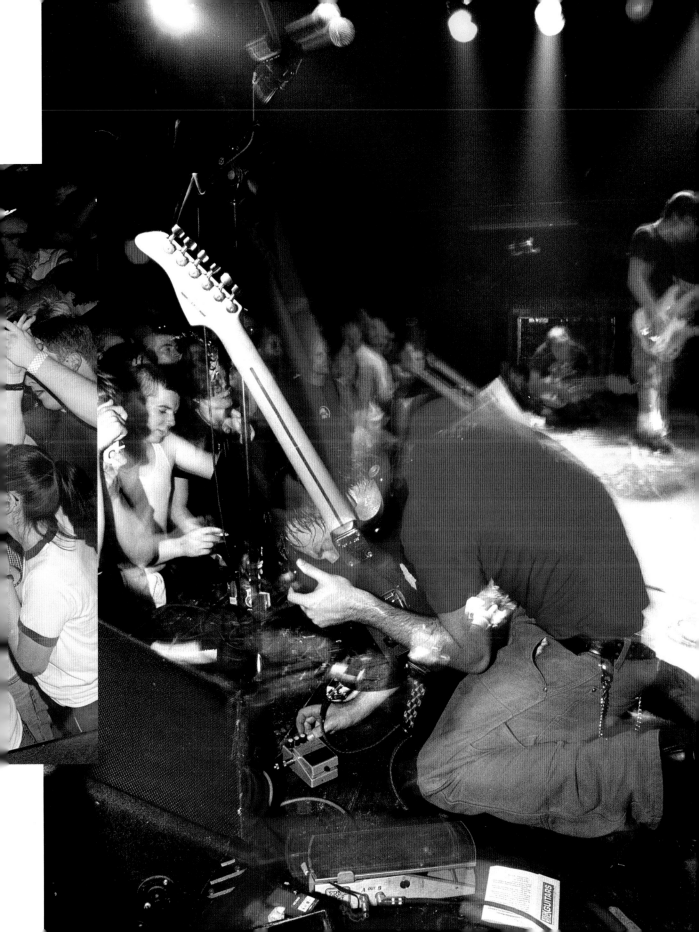

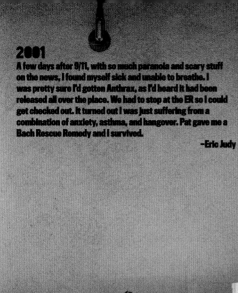

2001

A few days after 9/11, with so much paranoia and scary stuff on the news, I found myself sick and unable to breathe. I was pretty sure I'd gotten Anthrax, as I'd heard it had been released all over the place. We had to stop at the ER so I could get checked out. It turned out I was just suffering from a combination of anxiety, asthma, and hangover. Pat gave me a Bach Rescue Remedy and I survived.

–Eric Judy

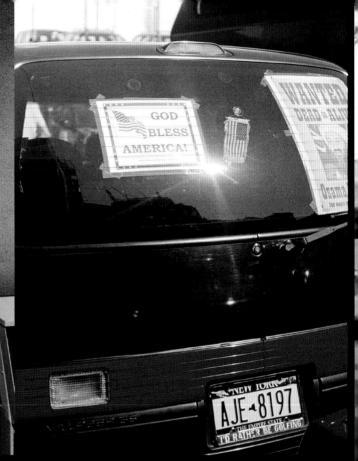

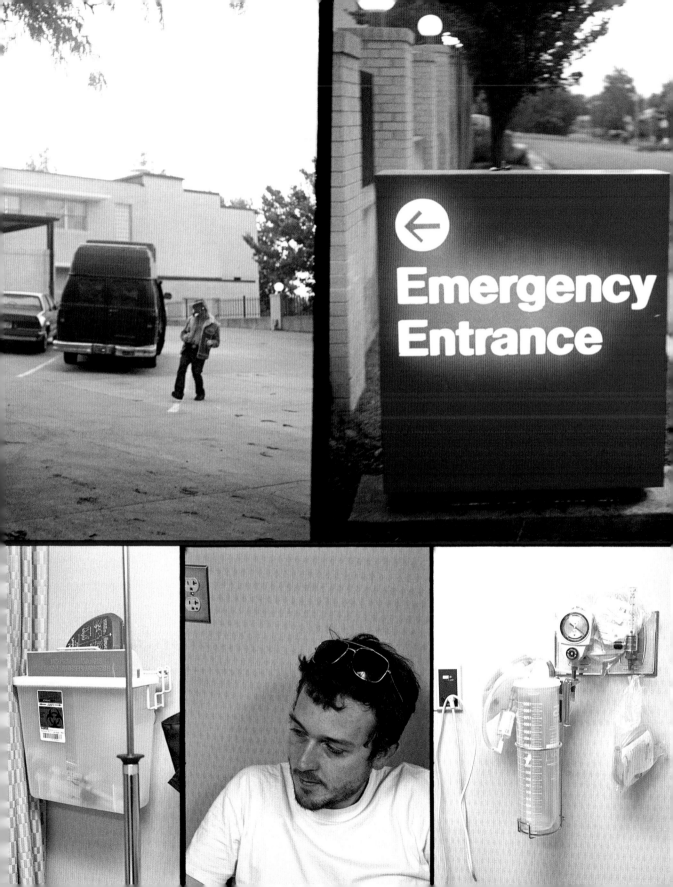

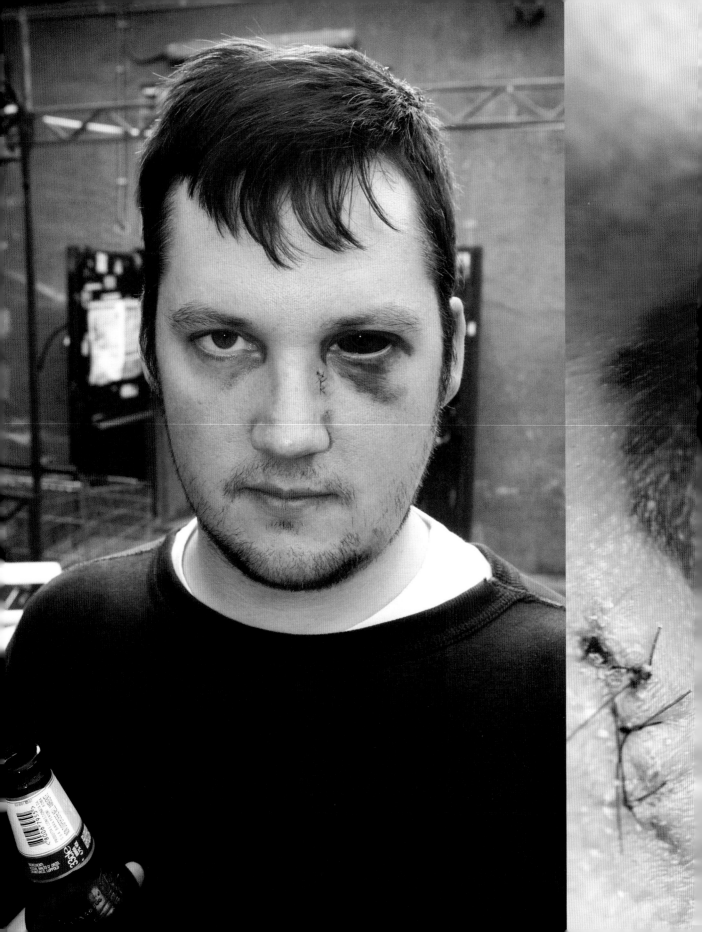

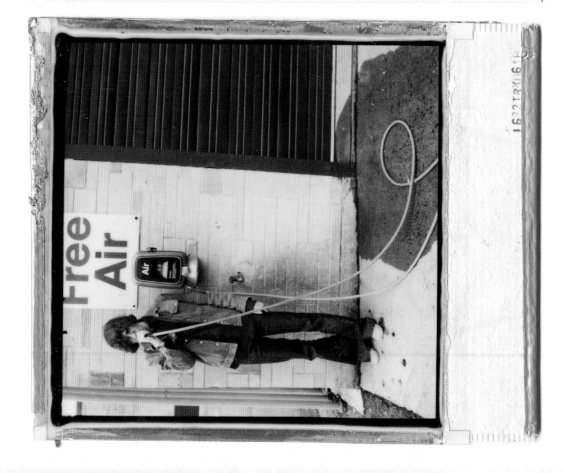

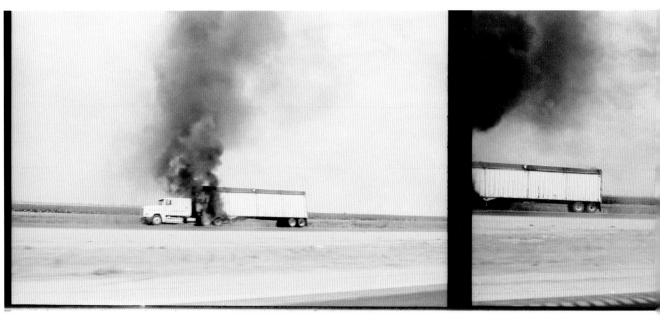

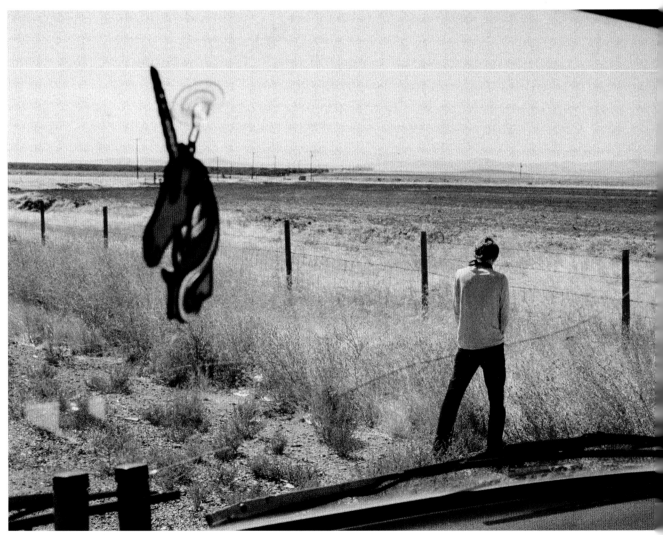

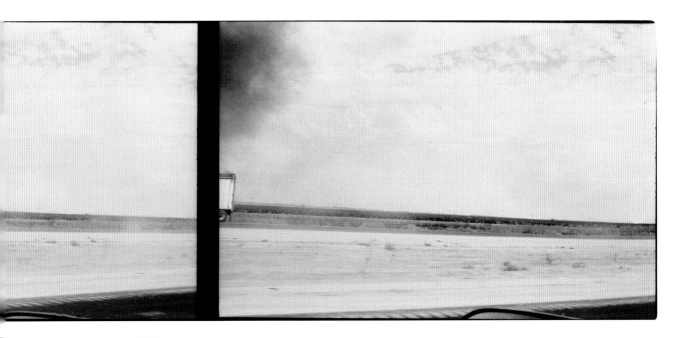

2001

The 2001 tour started in Portland on September 8. One of my jobs on this tour was to set up and play projections behind the band. Matt Clarke had created films to go with the music as the band played. One of the films was a building being blown up and then played in reverse, making it come back together.

The band was scheduled to play on September 11 in Los Angeles. We spent some time driving down and ended up at a hotel about four hours north of L.A. on September 10. Early on the morning of September 11, I was awoken by my friend and tour manager Juan. He said, "Call your wife, America is being attacked." We all watched the TV together. Some of us were in shock.

I really wasn't in shock or surprised at all.
Just surprised it hadn't happened sooner.
-Isaac Brock

After breakfast we began our drive to L.A. As it was early, and due to what was happening, we had no idea what was going on in L.A. As we drove, there was a lot of black smoke way off in the distance and it was getting closer. The smoke turned out to be a truck on fire. I snapped three frames as we sped by it.

The concert in L.A. was cancelled and everybody just went to their rooms. I ended up with Jeremiah, our friend Andy, and his friends. It was Andy's birthday.

The attacks added a very strange dynamic to the tour and everything that was going on in America. Flags hung everywhere and people seemed scared. The MM projections of the building blowing up caused some controversy. The film did show buildings being put back together and Isaac mentioned how that's what MM was about.

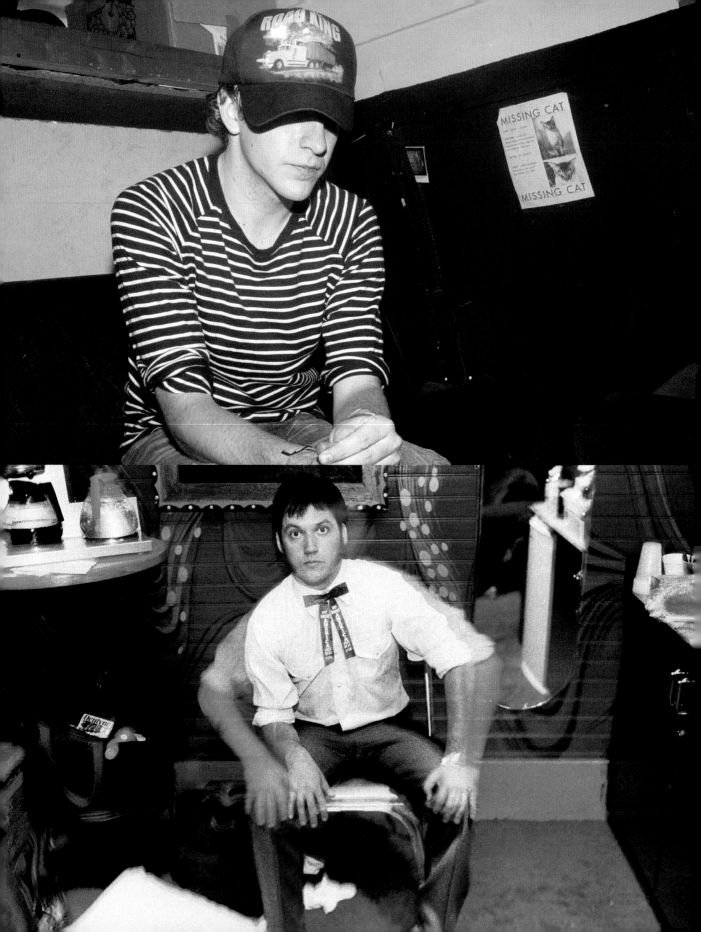

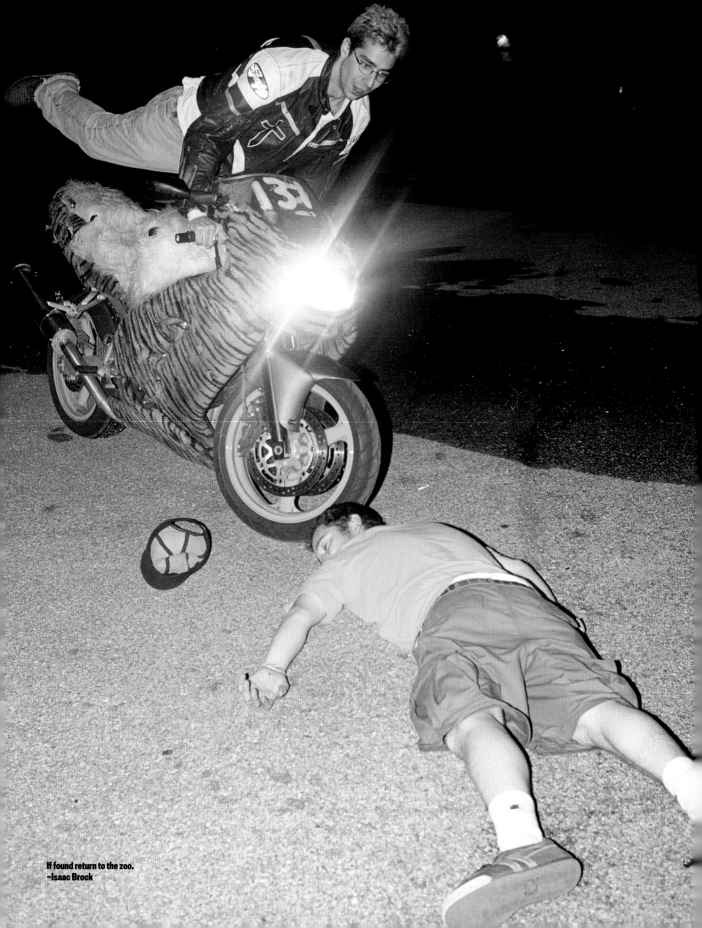

If found return to the zoo.
-Isaac Brock

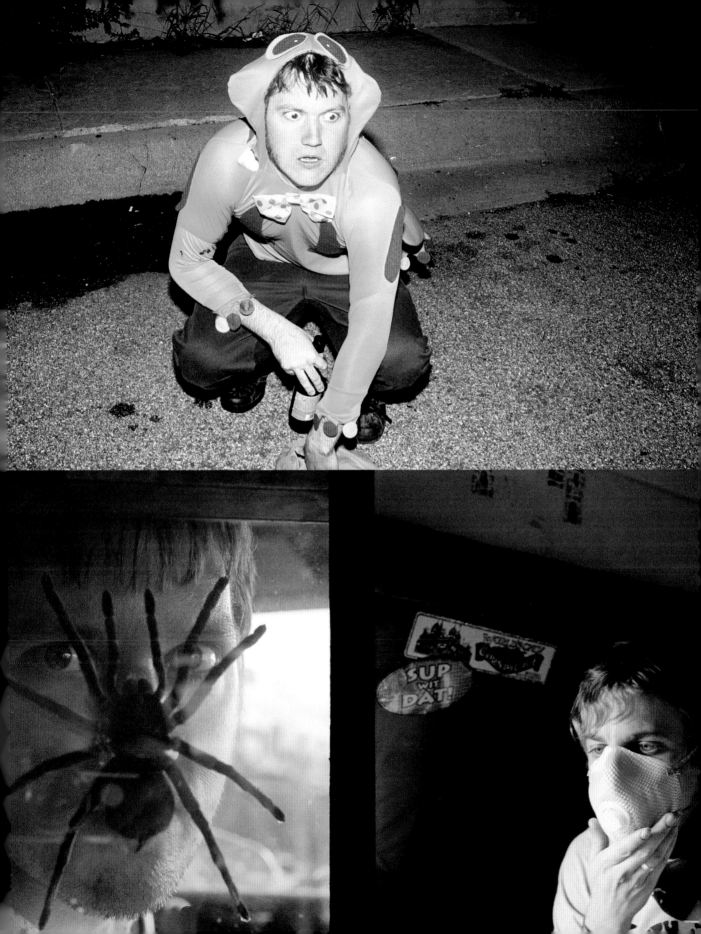

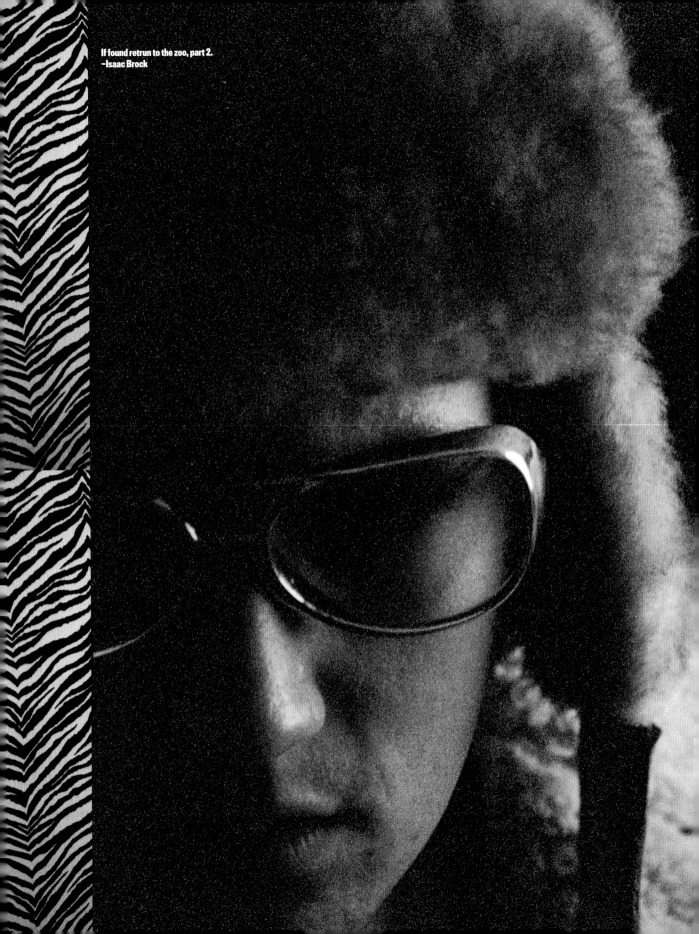

If found retrun to the zoo, part 2.
–Isaac Brock

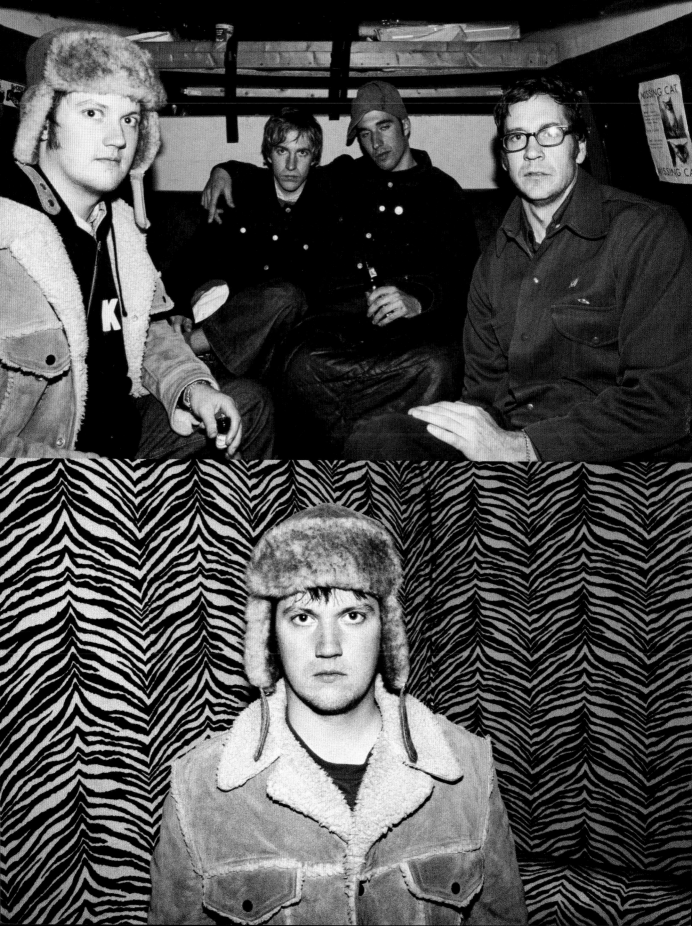

This was kind of the beginning of the end for the Vansion. It had broken down in some very beautiful part of Nevada right after some of us had eaten mushrooms. The tow truck driver let us stay in the van on his truck bed for the several hour drive to Salt Lake City. it was fun as hell. Thanks AAA Plus for the insane amount of miles you allowed us to toe broken vehicles.
-Isaac Brock

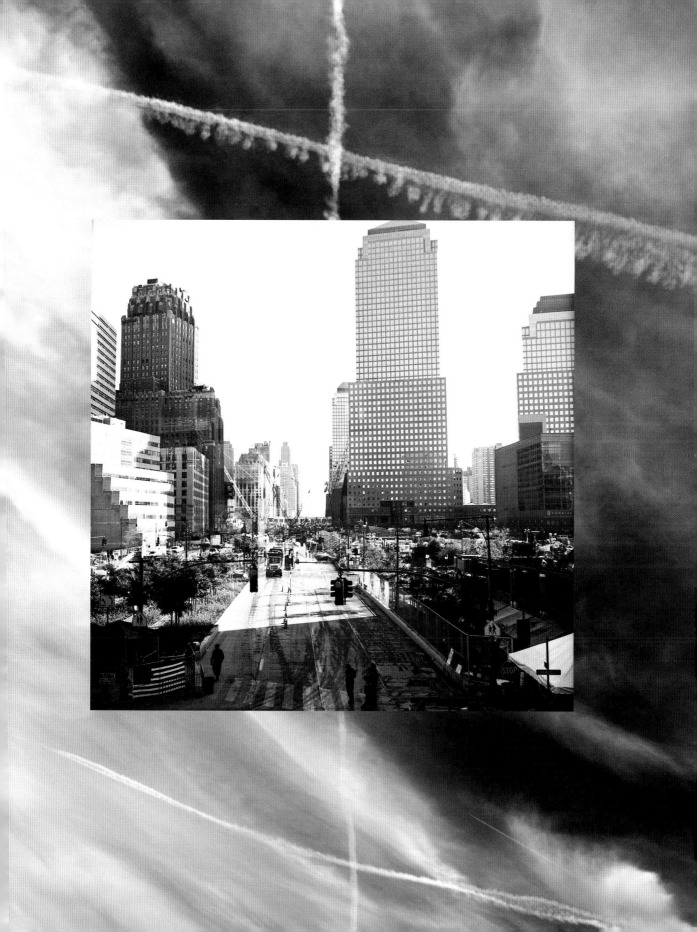

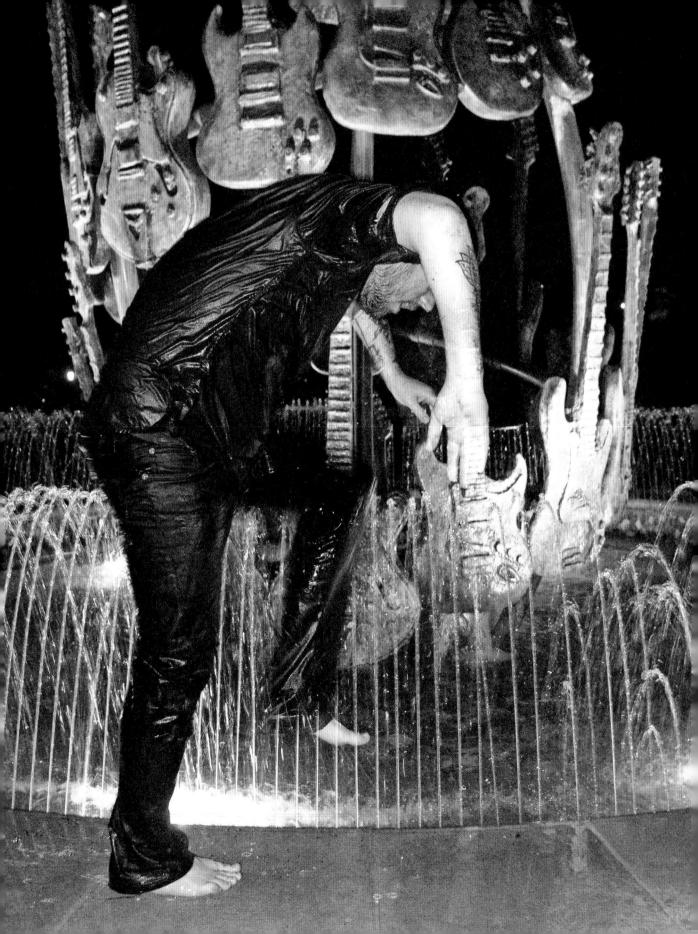

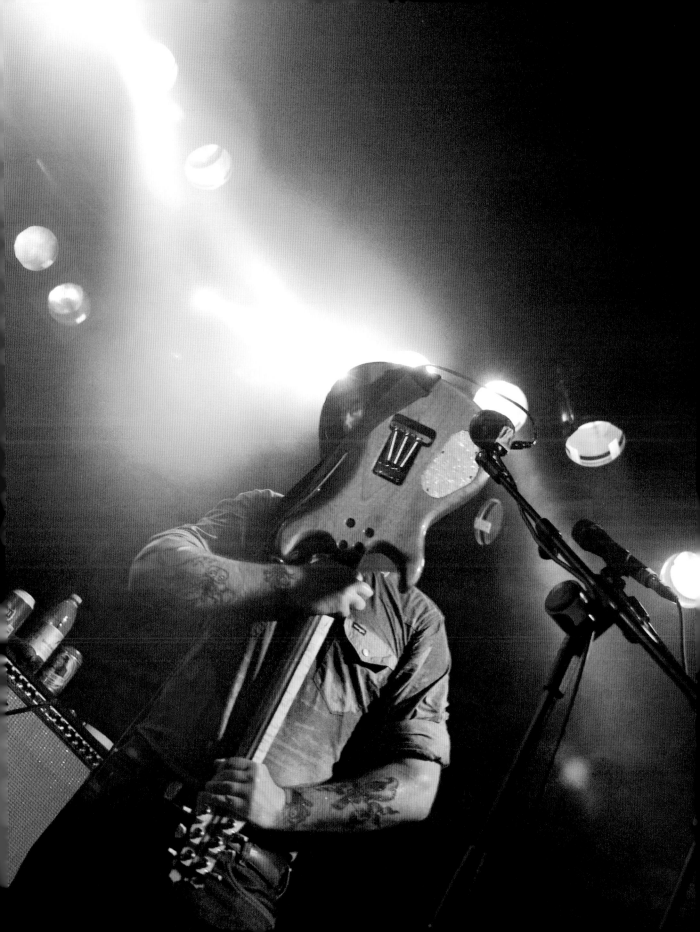

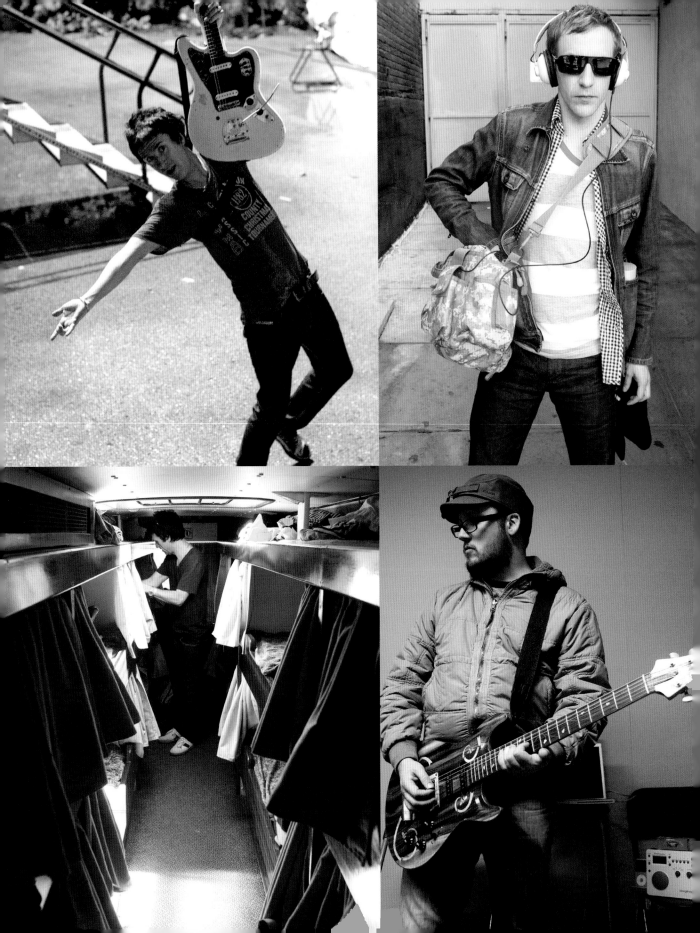

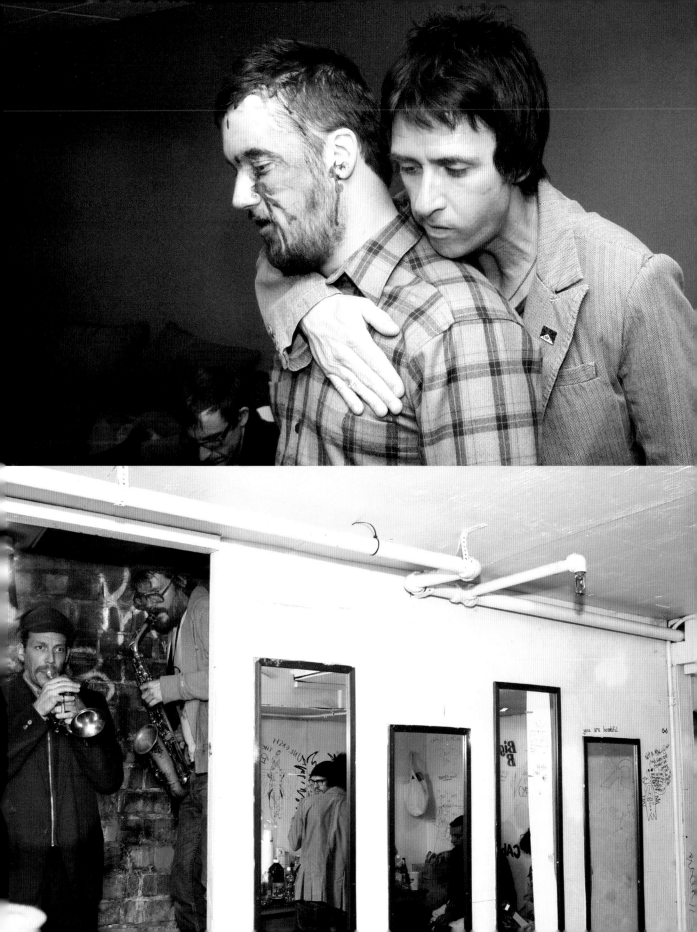

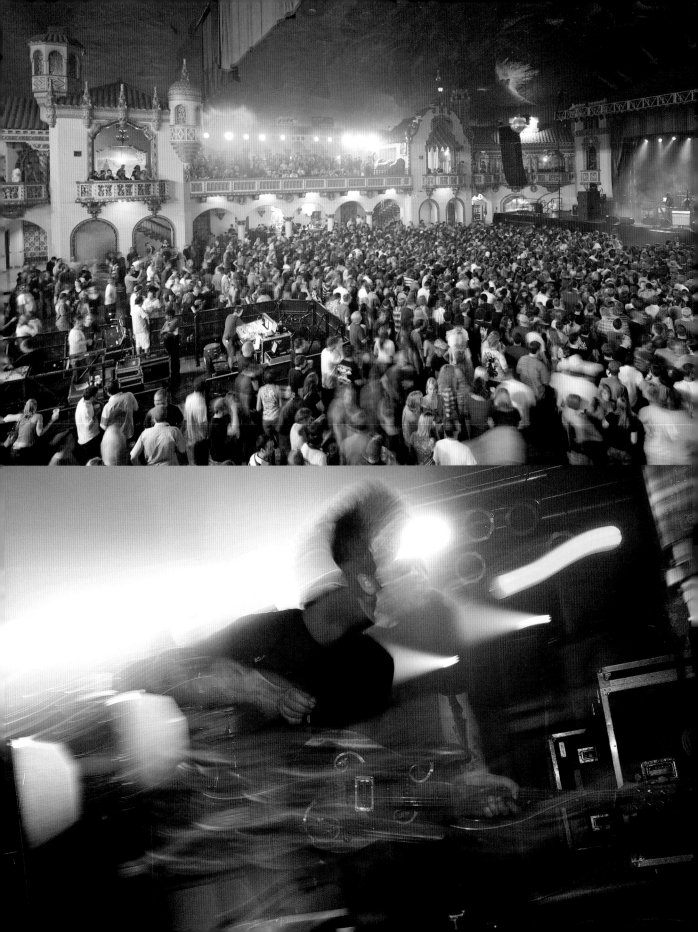

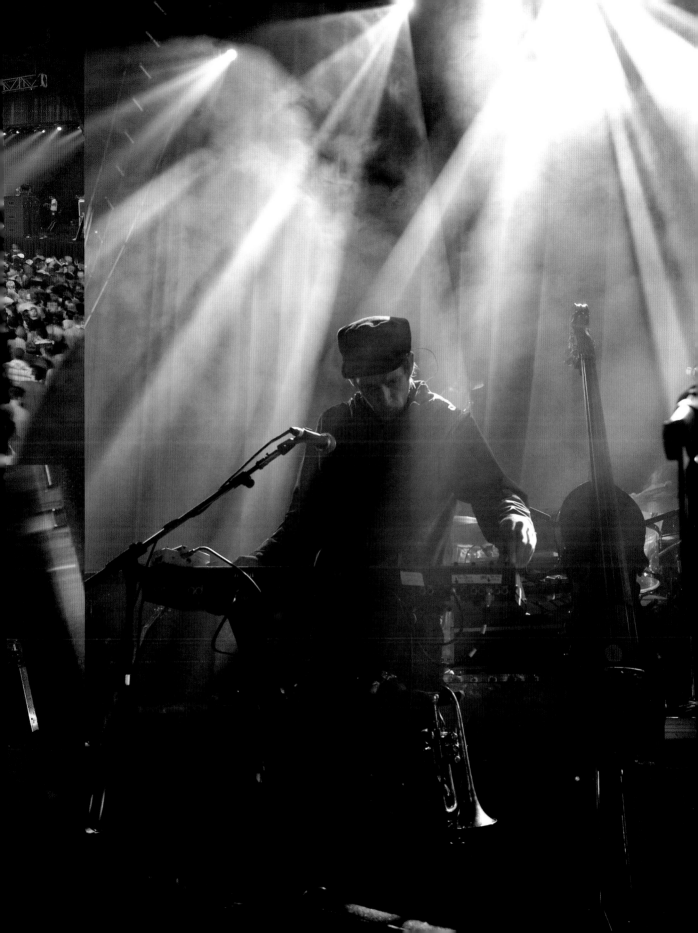

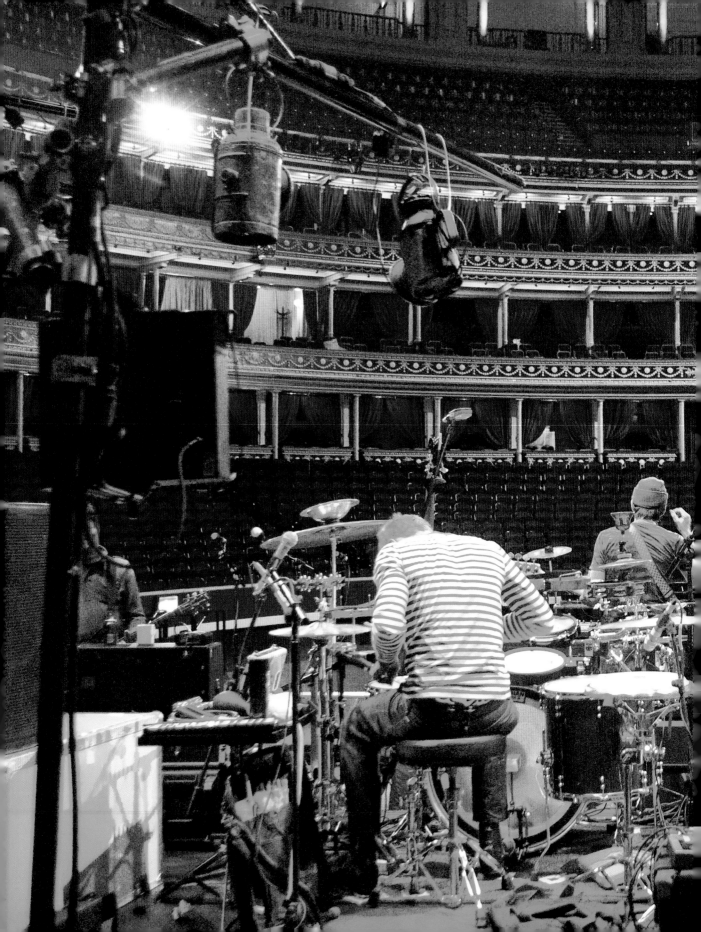

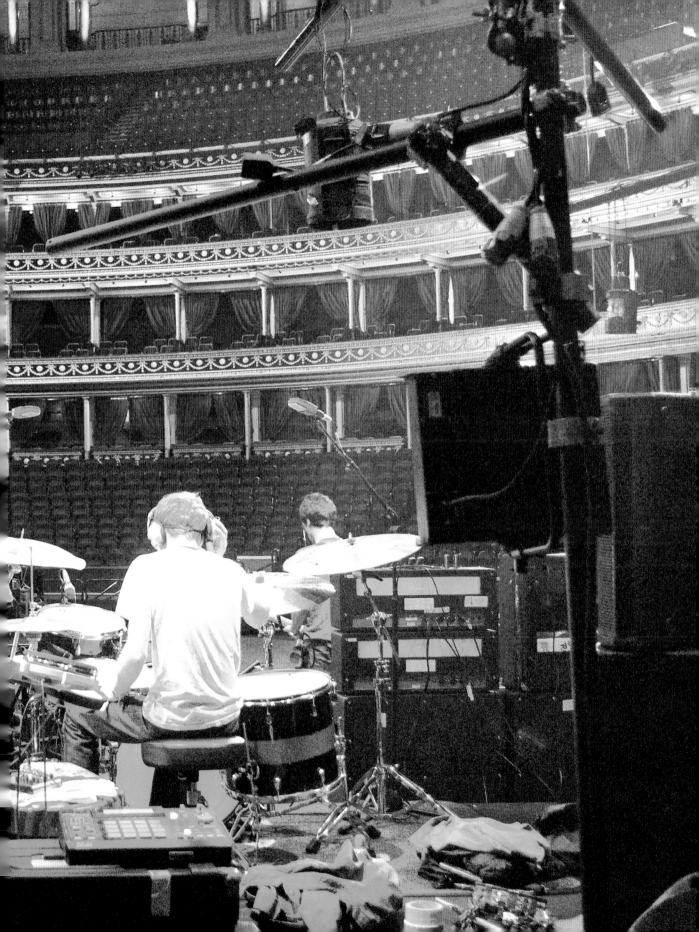

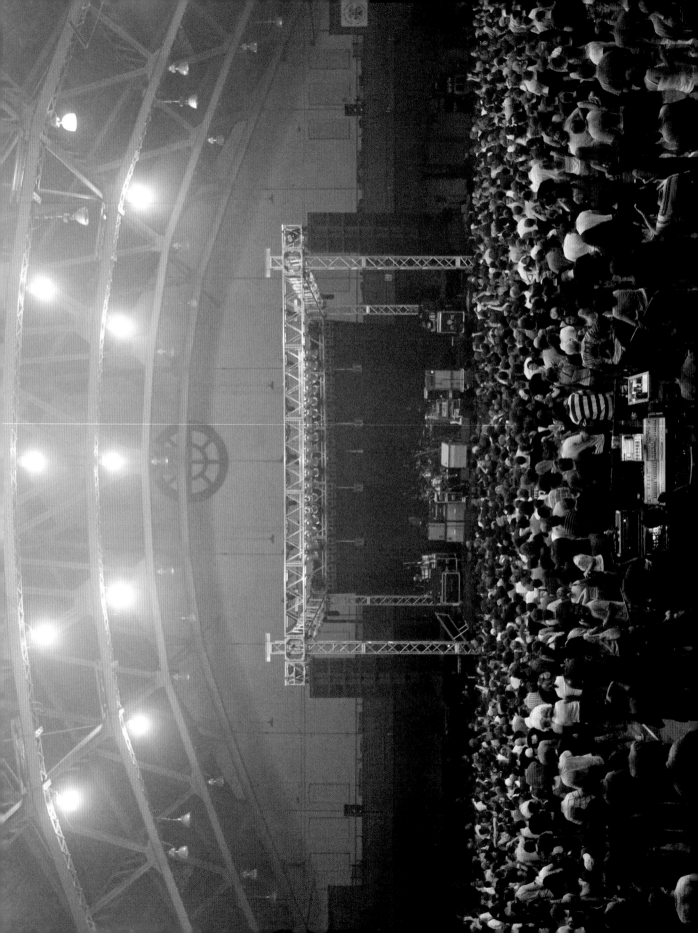

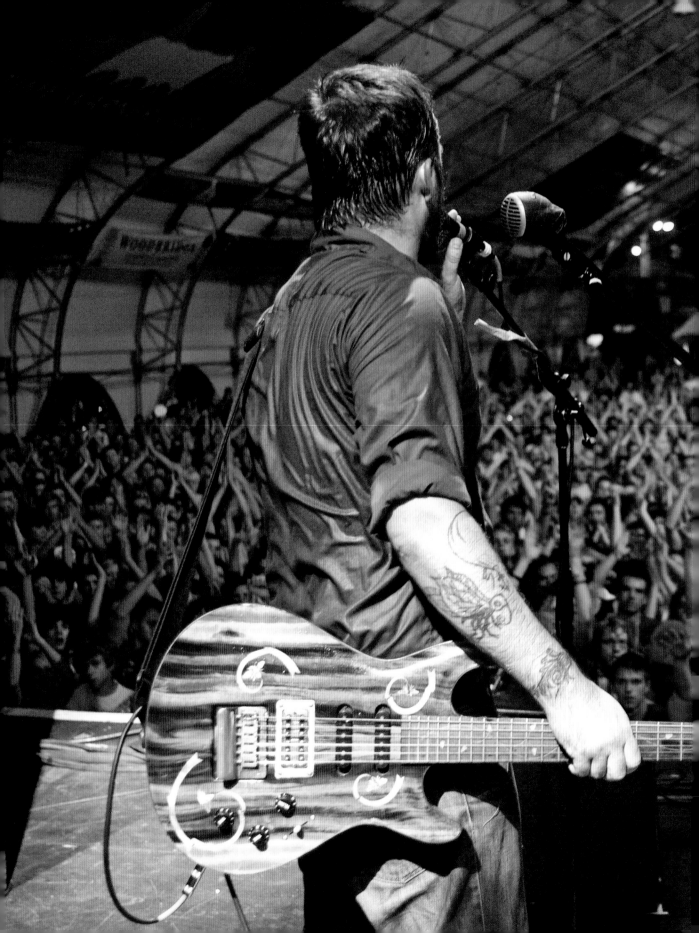

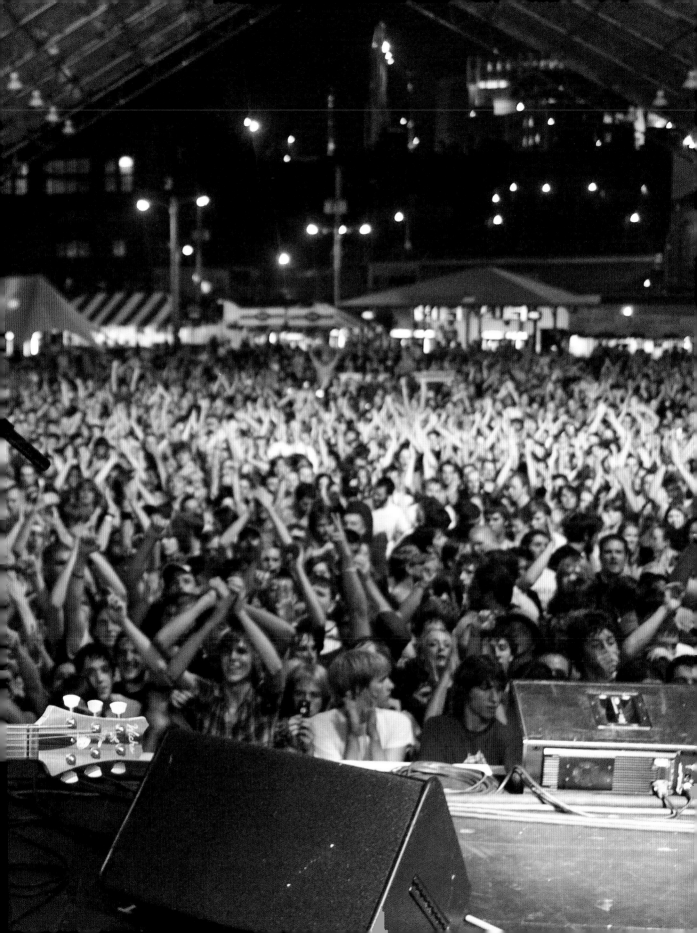

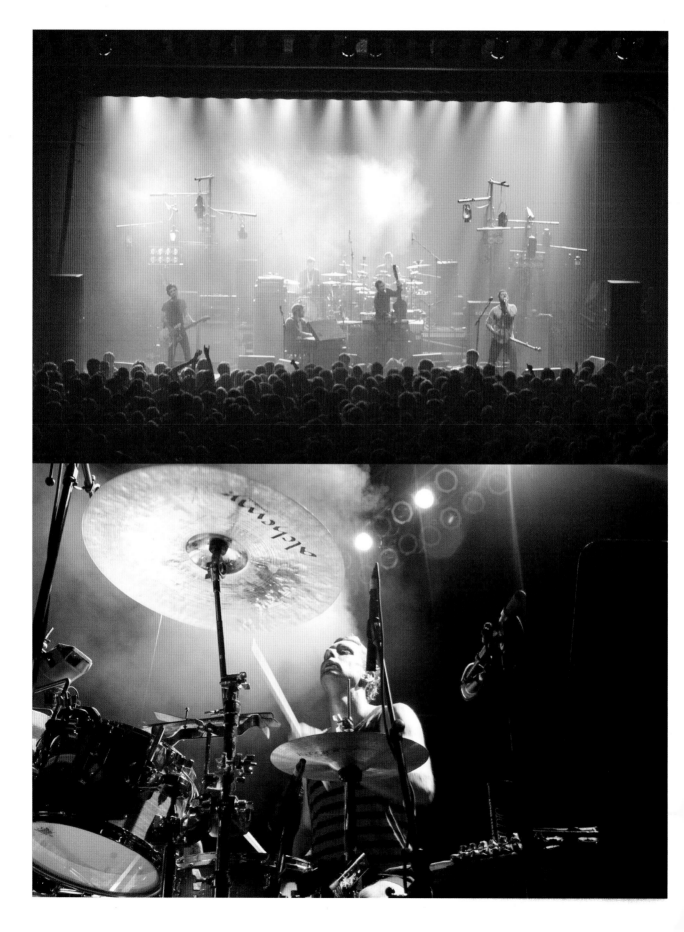

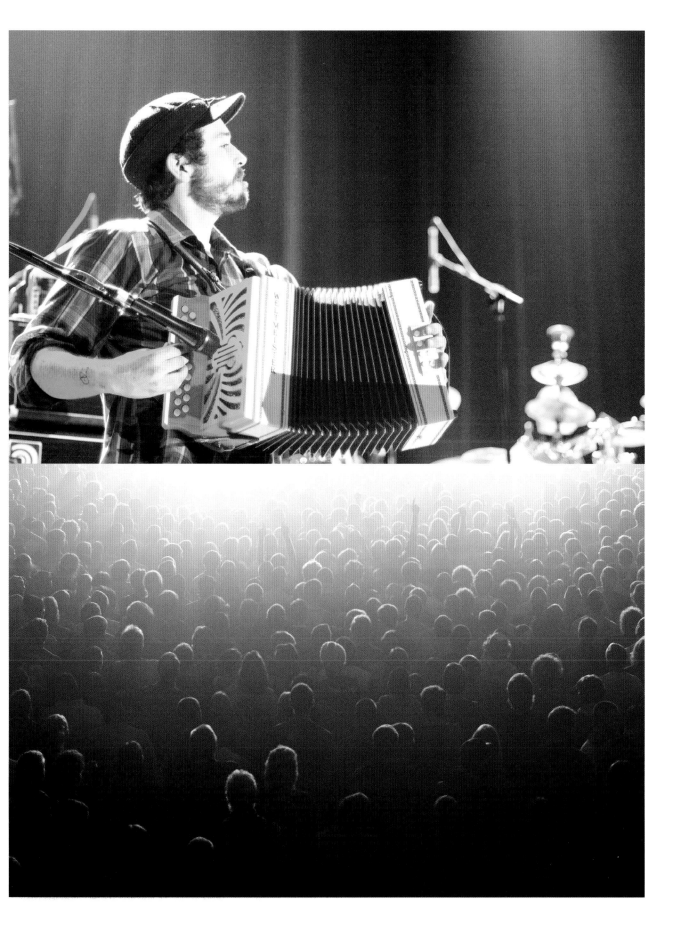

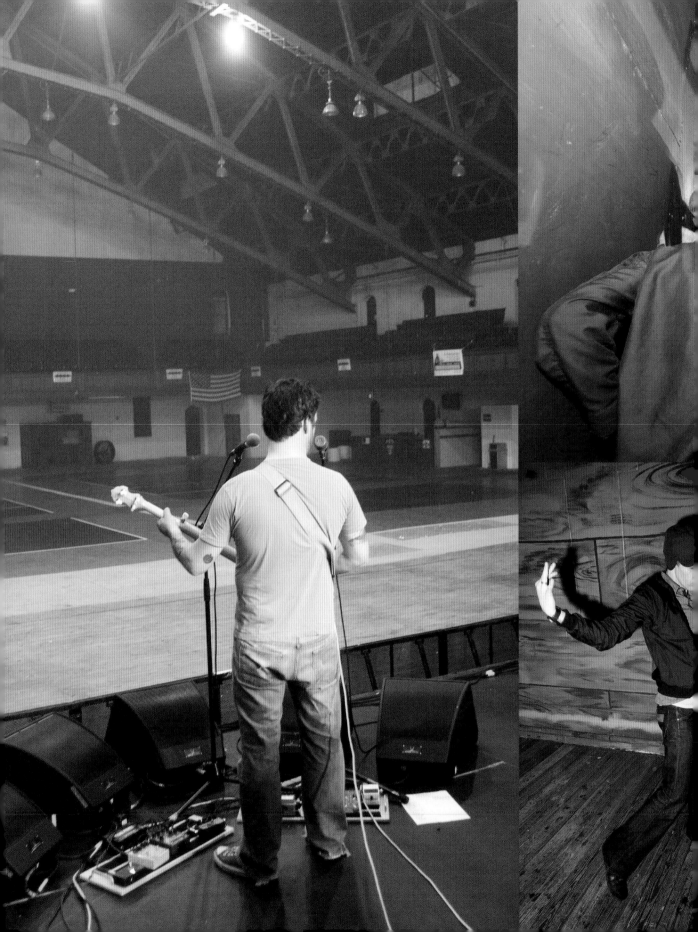

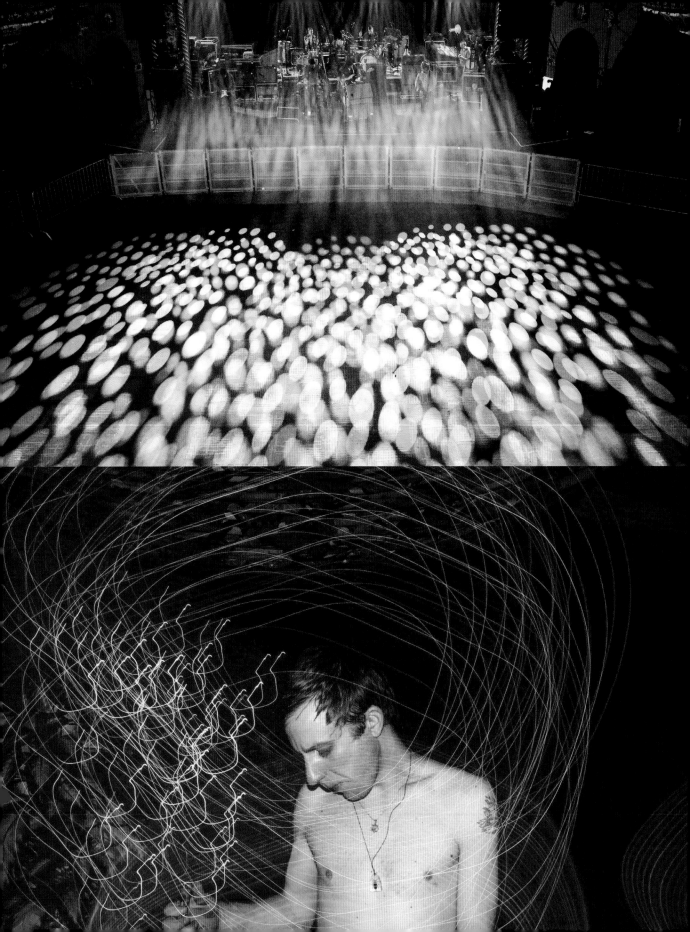

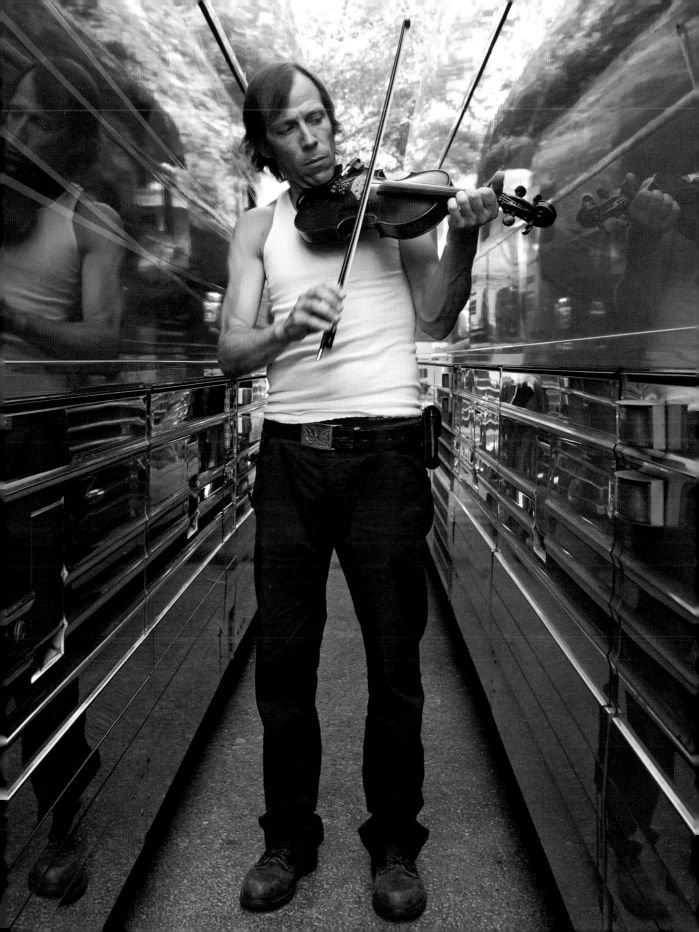

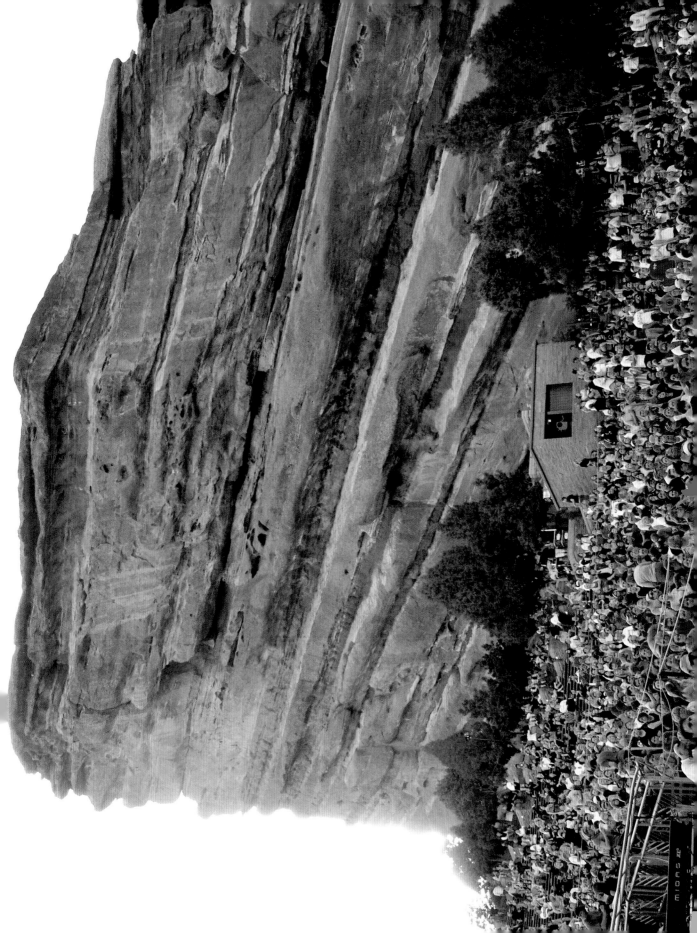

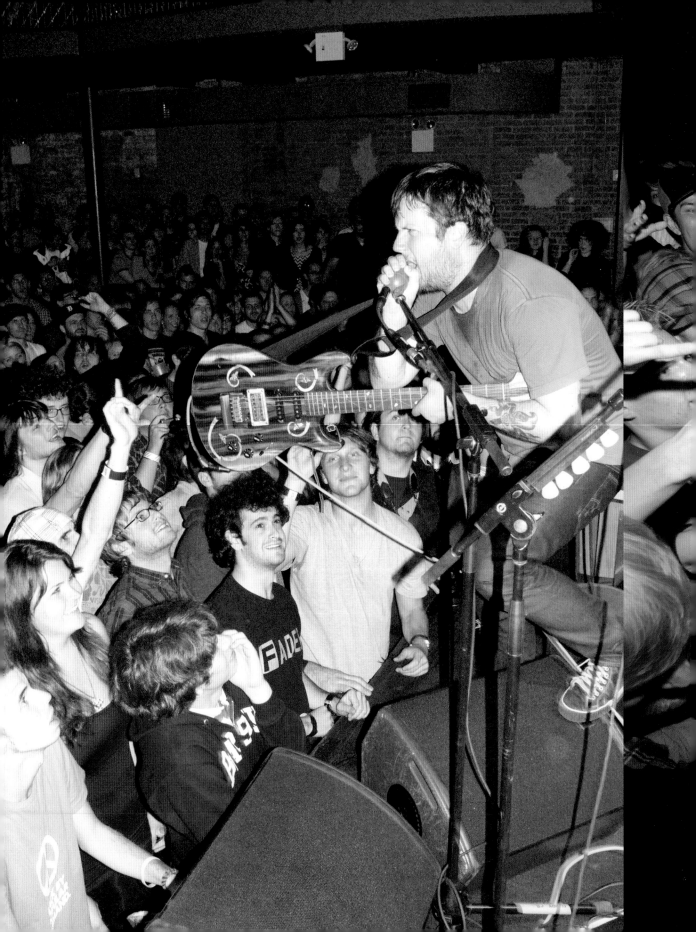

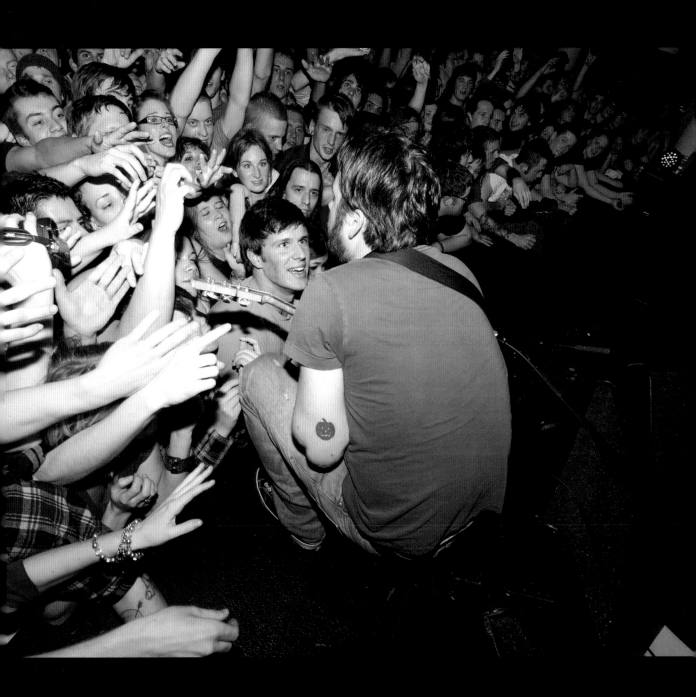

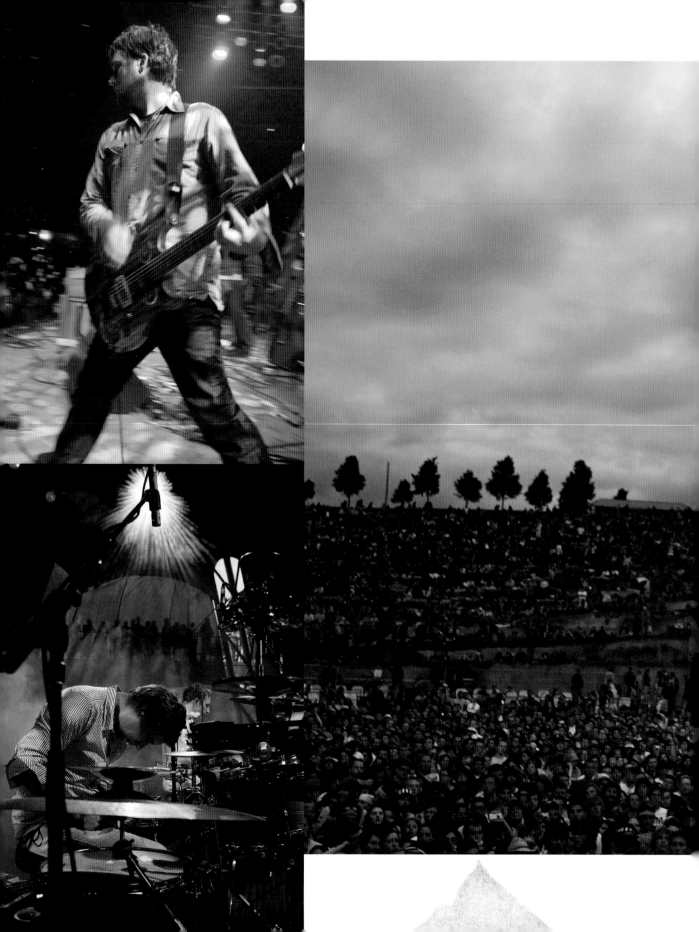

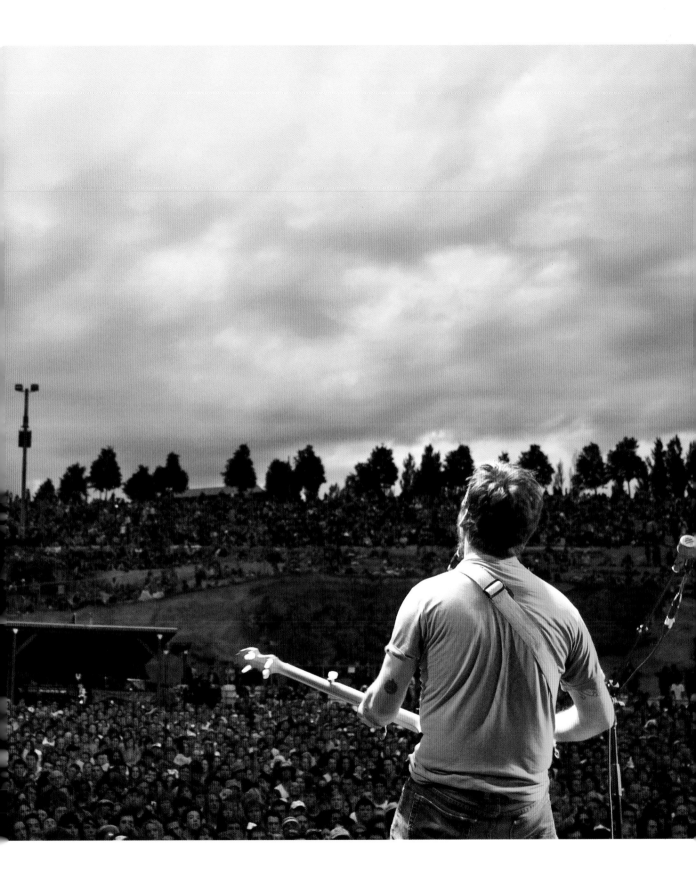

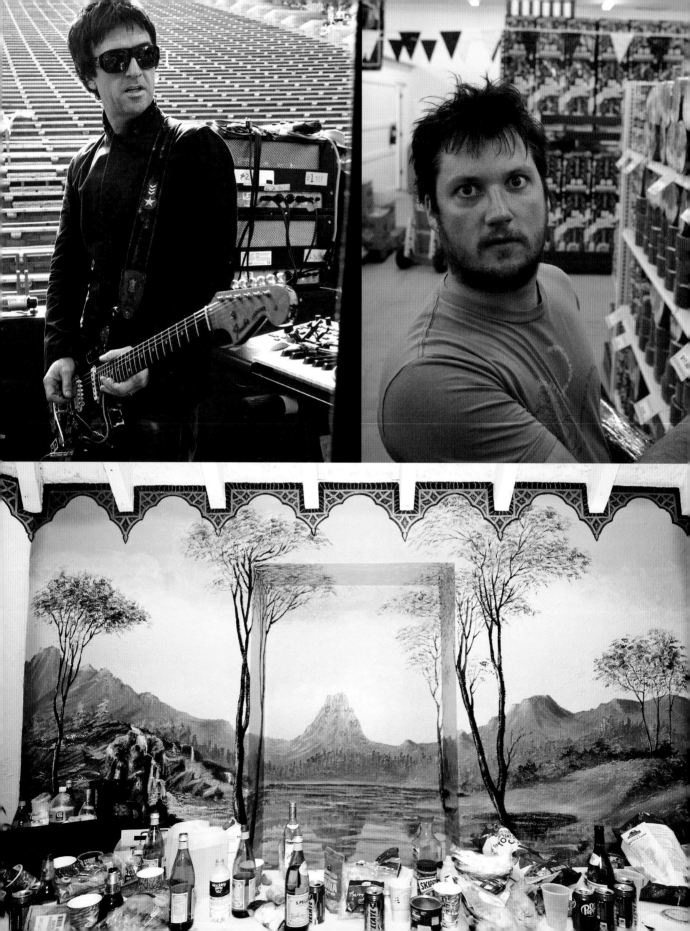

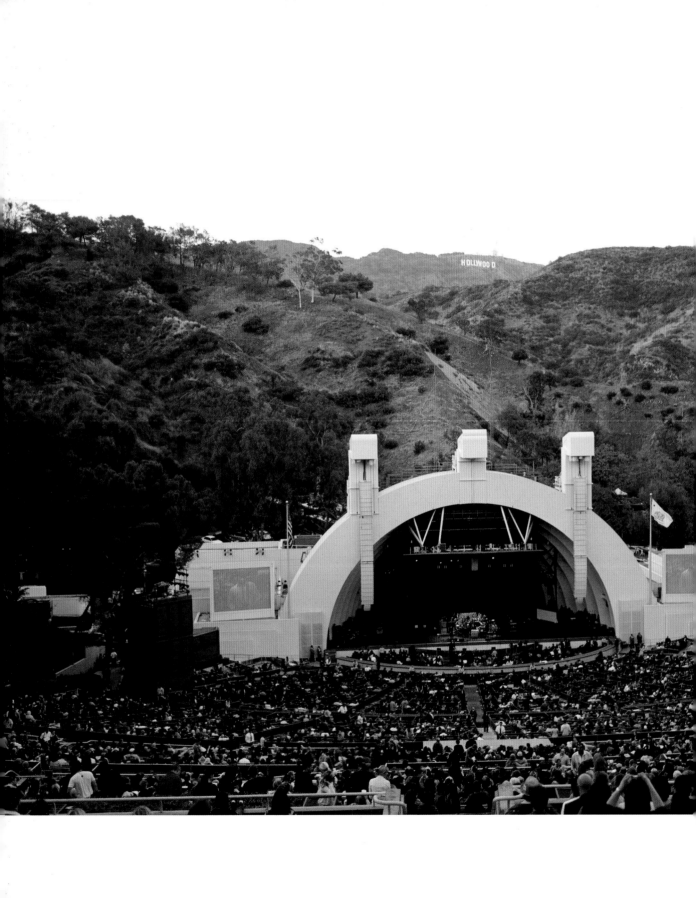

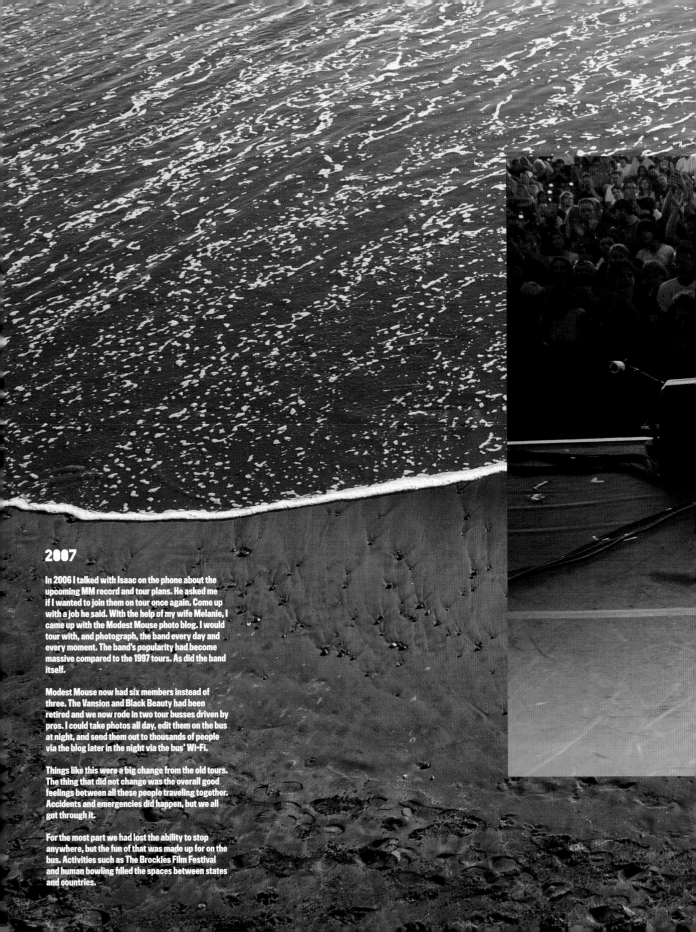

2007

In 2006 I talked with Isaac on the phone about the upcoming MM record and tour plans. He asked me if I wanted to join them on tour once again. Come up with a job he said. With the help of my wife Melanie, I came up with the Modest Mouse photo blog. I would tour with, and photograph, the band every day and every moment. The band's popularity had become massive compared to the 1997 tours. As did the band itself.

Modest Mouse now had six members instead of three. The Vansion and Black Beauty had been retired and we now rode in two tour busses driven by pros. I could take photos all day, edit them on the bus at night, and send them out to thousands of people via the blog later in the night via the bus' Wi-Fi.

Things like this were a big change from the old tours. The thing that did not change was the overall good feelings between all these people traveling together. Accidents and emergencies did happen, but we all got through it.

For the most part we had lost the ability to stop anywhere, but the fun of that was made up for on the bus. Activities such as The Brockies Film Festival and human bowling filled the spaces between states and countries.

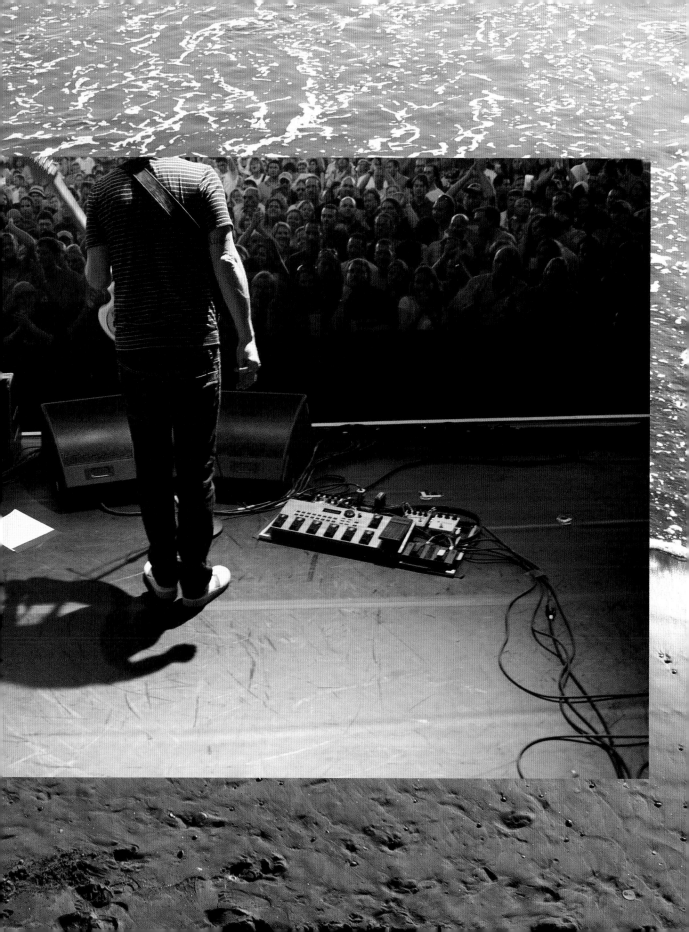

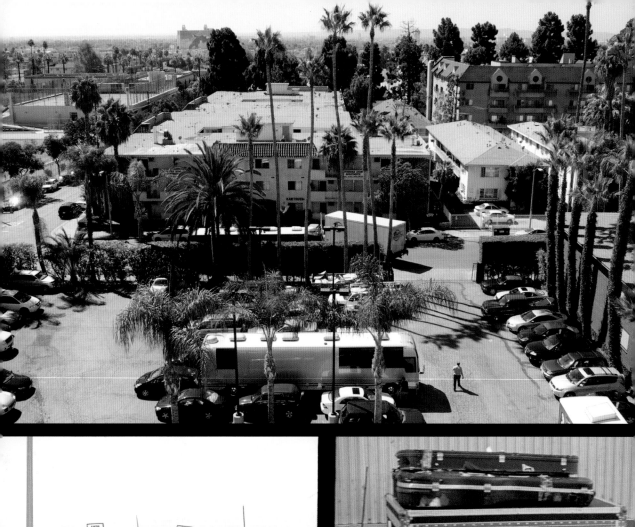

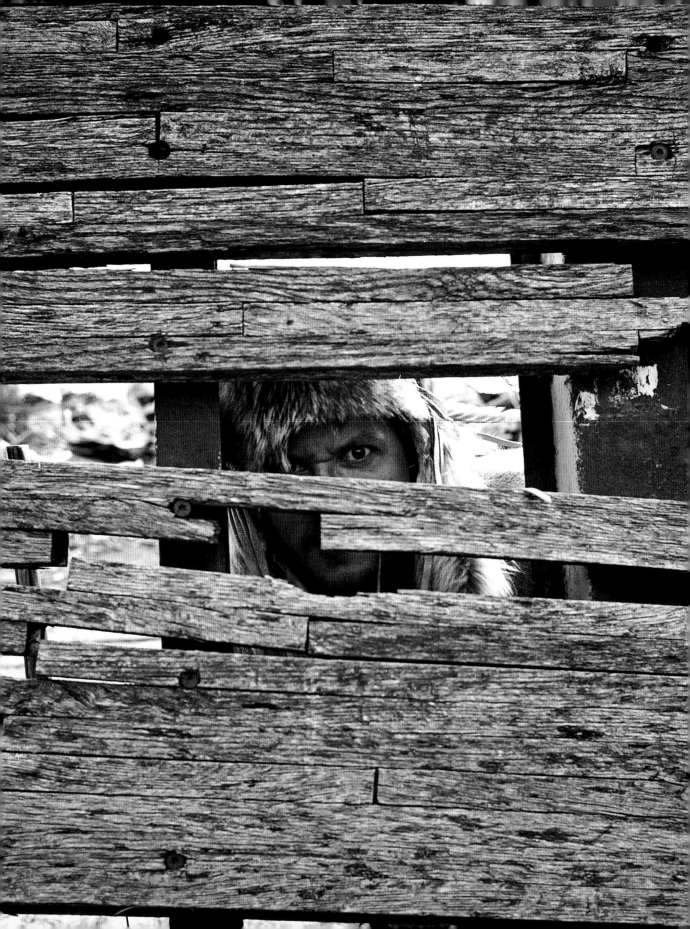

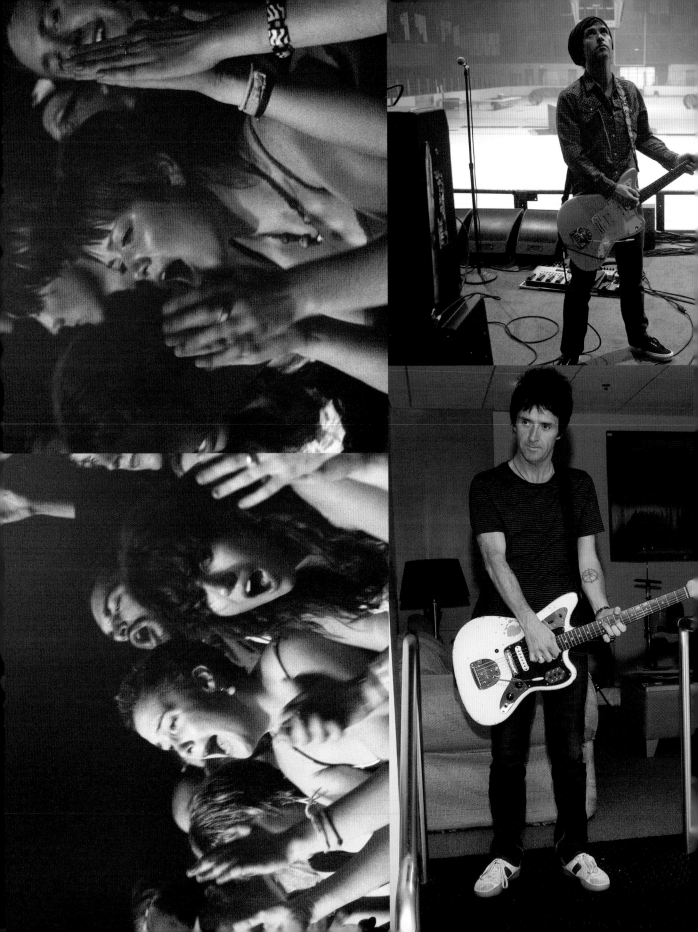

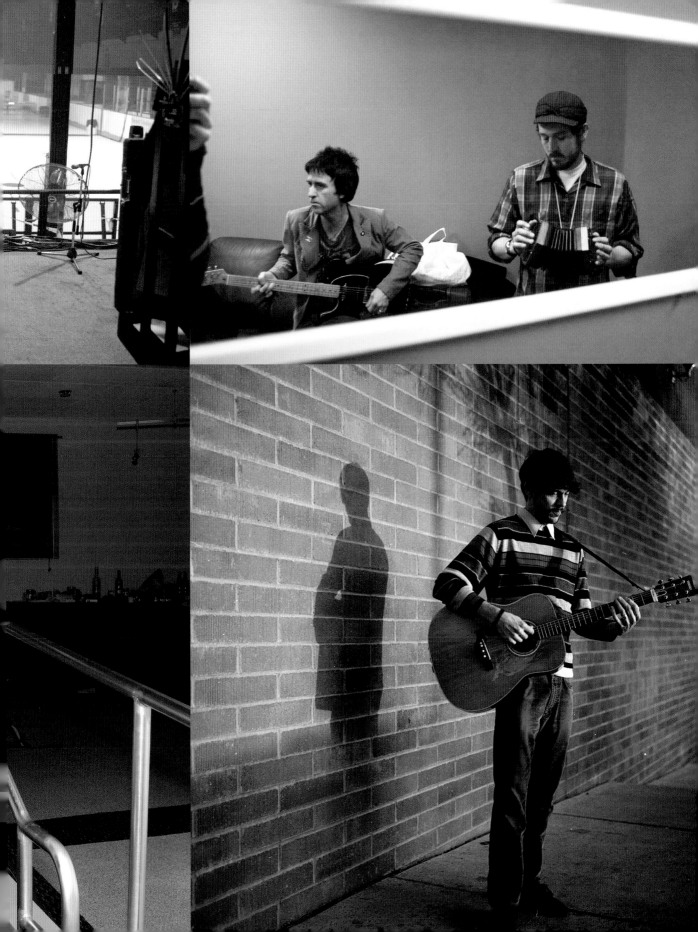

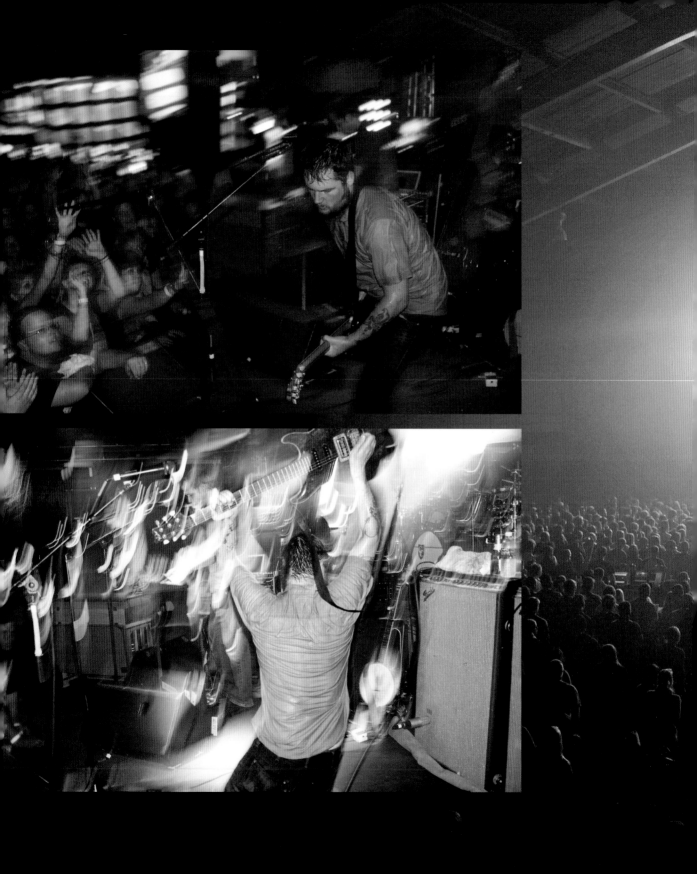

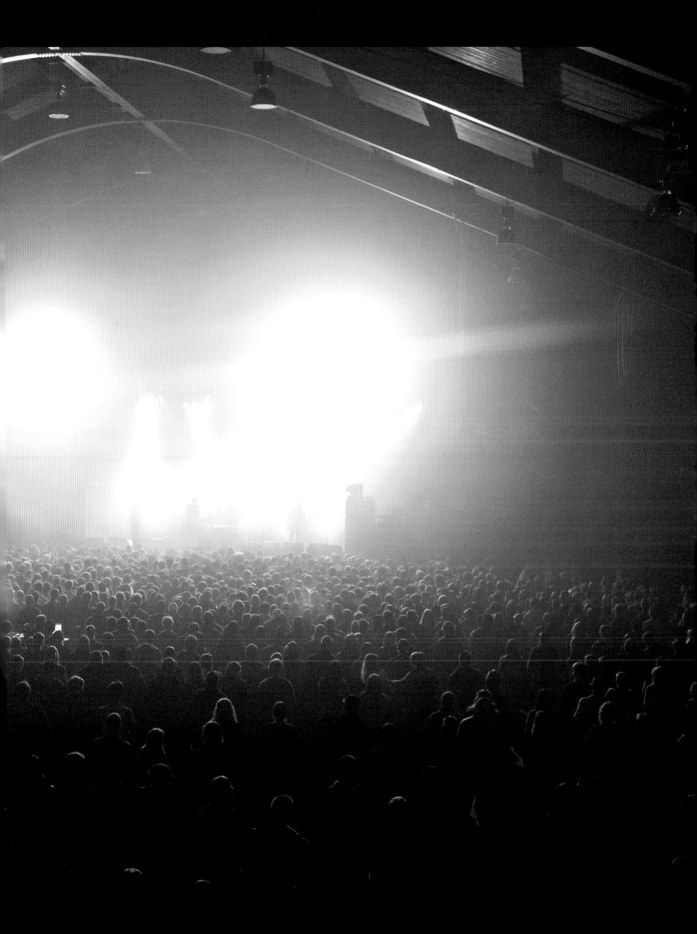

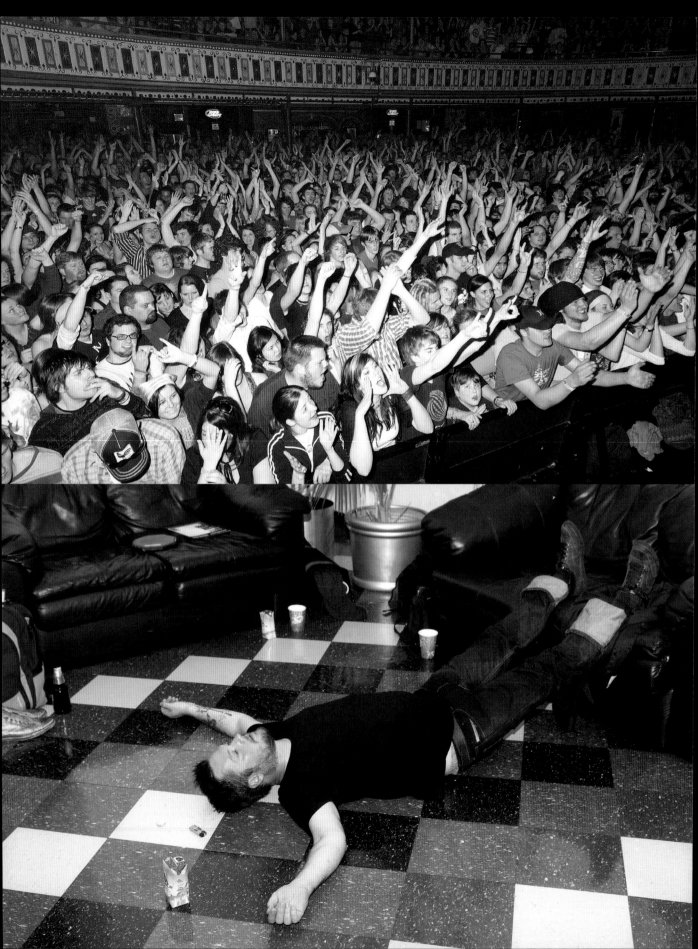

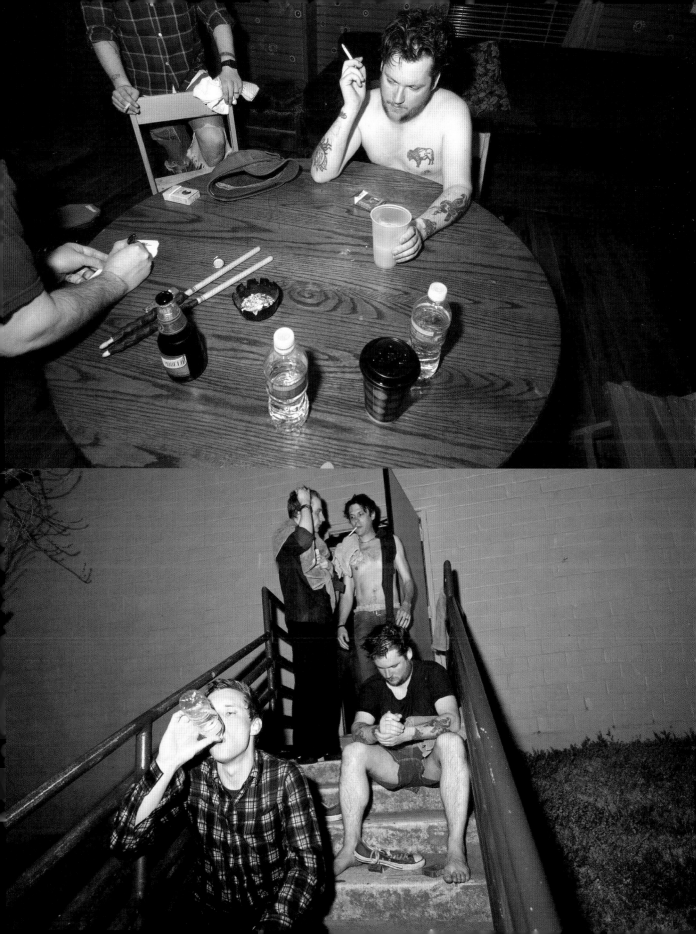

...te-made an offer. I made...my...
digits. he told me to go somewhere far away and
forget my way back or he'd make sure that "Chucky
Cheez" is closed on my birthday for the rest of my
life, even when i'm really old when it's most important.
I'm gonna stick around any way.

SCRUM, SCRUM, SCRUM!!!

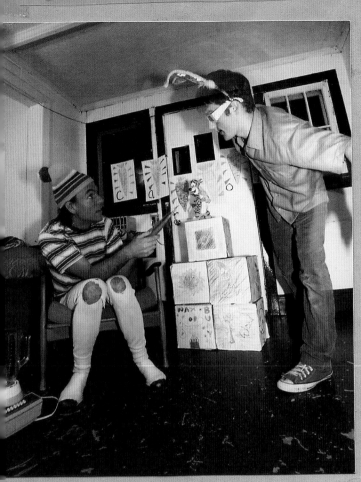

KISS, KISS, KISS!!!

Moms make make making tooth
polishing treats for her
bucktoothed baby.
KISS, KISS, KISS!!
Buddy bucktooth jumps to
spell it out, jumps the gun
and jump the ship in ship
shape.
SCRUM, SCRUM, SCRUM!!

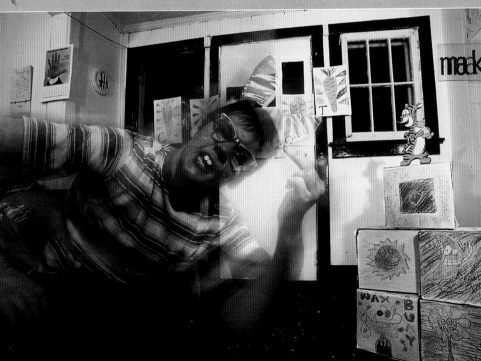

mackee mackee makkin

make making tooth
treats for he
d baby. spell it
KISS, KISS!!
tooth jumps
, jumps the
h ship in sh

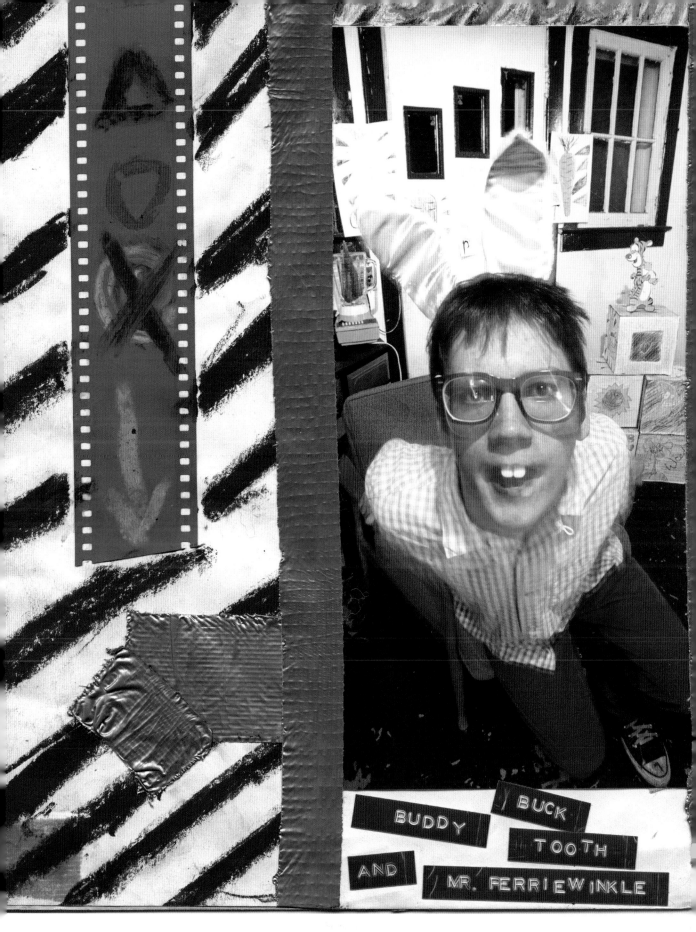

BUCK
BUDDY
TOOTH
AND
MR. FERRIEWINKLE

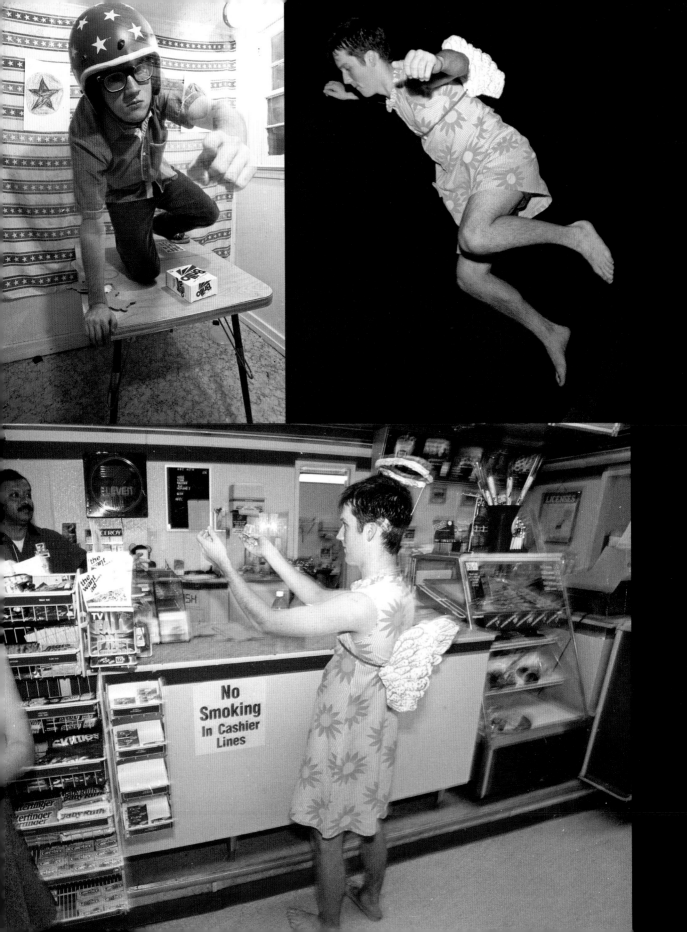

In 1992 I packed up my things and moved 15 hours east of my hometown to Washington, D.C. The punk music scene of D.C. inspired me.

My new home was the punk group house known as Positive Force. PF residents included activists, feminists, artists, and musicians. Everybody was doing something creative. My outlet was photography.

Soon I had a darkroom in my closet and I was developing and printing pictures from all the punk shows and protests I was witness too. Fugazi was at their height of creativity and new bands like Bikini Kill and The Nation of Ulysses played all the time.

Positive Force had a revolving door of likeminded people coming and going. One new housemate was Isaac Brock, a 16-year-old from Issaquah, Washington. Isaac struck me as very funny and super creative. The things that he would say and do made me laugh and think at the same time. We bonded over photography and our love of music. Isaac had his own great photos of bands from the Northwest and also loved the work of photographer Charles Peterson. I shared my pictures that I had shot of bands in D.C. with Isaac. He was very into them and I gave him a stack to keep. Isaac liked the blurring effect in my shots and wanted to explore this concept with me.

We talked about doing some sort of project together. I wasn't sure what he wanted to do but he started to gather outfits from thrift shops, and he also constructed sets/props out of boxes and Styrofoam. We had planned to take photos on the ground floor of the house late at night while everyone else was sleeping. Our roommate worked at a photo lab so she could get the film developed and prints made. This was great as it let us shoot as much as we wanted. We had a few of these late night photo sessions. I would set up the tripod and Isaac would direct us. The results were amazing and surreal. I loved the way these pictures looked: lots of color, motion, and strange settings.

At the time, it felt like we were taking these shots just in the name of an interesting photo. Isaac had talked about making a zine or little book. Months later

Eggtooth was finished. Isaac had created hardcopy layout pages that we took to our friend who worked at Kinko's. She made color copies and our zine was finished. I think we managed to make about ten copies or less. I look back at these photos, teamed with Isaac's writings, and still find them very interesting and hilarious. One scene in the book was of Isaac hovering over me with a carrot in his hand. The idea was that he would hit me with the carrot and the camera would capture this in a blur. After about four or five broken carrots over my head we still did not get the shot. It did not matter, what we did get was another great image. Eventually Isaac ended up back in the Northwest and I moved to another house to work for Simple Machines records. Isaac and I stayed in touch and he sent me a few tapes of his new band, Modest Mouse. The artwork was similar to *Eggtooth* and the music was inspired.

In 1996, I was in Olympia, Washington and Modest Mouse was playing a show. They were opening up for The Make-Up and Dub Narcotic. I would finally get to meet Isaac's bandmates and see him play live. The band played and I took my first photos of them. Isaac and I continued to have conversations about photo projects. I really wanted to do more with him, as his creative energy was so apparent. Somehow the idea came up of me going on the road with MM to help run things and to take pictures. We could take the ideas of *Eggtooth* across the country. Imagine the crazy photo ops we could find...

Twenty years later, I have traveled thousands of miles and shot thousands of frames of my close friend Isaac, and his band Modest Mouse. This book contains my journey documenting Modest Mouse and the creative force of Isaac.

I feel more than privileged that he chose me to share it with.

–Pat Graham

MODEST
MOUSE

Published in the United States by powerHouse Books,
a division of powerHouse Cultural Entertainment, Inc.
37 Main Street, Brooklyn, NY 11201-1021
telephone 212.604.9074, fax 212.366.5247
e-mail: info@powerHouseBooks.com
website: www.powerHouseBooks.com

First edition, 2014

Library of Congress Control Number: 2014942940

Hardcover ISBN 978-1-57687-651-0

Printing and binding by Midas Printing, Inc., China

Book design by Krzysztof Poluchowicz

10 9 8 7 6 5 4 3 2 1

Printed and bound in China

For Isaac and Melanie, two unflinchingly creative forces of nature in my life.

THANK YOU:

Sue and Bill Graham, Angela and Kevin Standage for the tremendous help and support. Honor and Huw for just being yourselves.

Eric Judy, Jeremiah Green, Juan Carrera, Sean Hurley, Johnny Marr, Joe Plummer, Tom Peloso, Jim Fairchild, Tim Loftus, Trevor Keen, Evan Player, Modest Mouse crew, Don Irwin, Matt Gee, Brandon Harman, Justin Heit, Raen Optics, Libre Design, Chad States, Craig Cohen, Krzysztof Poluchowicz, powerHouse Books, Dan Farrell, Robin Taylor, Lisa Markowitz, Rich Jacobs, and Prudence and Patience.

This book represents so many years of my life while touring and hours spent editing, in the darkroom, in production and postproduction. Therefore, an extra thank you is offered to my wife, Melanie, who has supported my efforts through these years.

Some of the people in these photographs include (in order of appearance) Issac Brock, Eric Judy, Jeremiah Green, Dan Galluci, Pat Graham, Chris Majoris, Sean Hurley, Marty Crandell, Juan Carrea, Tim Loftus, Brandon Harmon, Matt Gee, Rick Ferrari, Trevor Keen, Johnny Marr, Tom Peloso, Joe Plummer, Jim Fairchild.

Thank you also: Apple and Patrick Pendergast for the MacBook, Aperture for use of the Hasselblad; Justin Heit and Raen Optics for the shades and the beautiful zines we created together; and to Simon Browitt et al at Calumet Photographic for the use of the Imacon Scanner.